SOS. CLANX

CW00821250

al Library

PHOTOGRAPHER

30130 133034354

LEGENDS
PHOTOS FROM THE VAULT

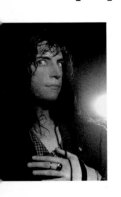 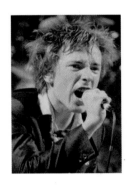 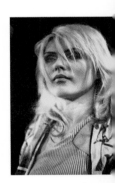

Rikki Ercoli

Manic D Press *SAN FRANCISCO*

OF PUNK

In 1978 I didn't even own a camera. I just knew that something was going to happen to Sid Vicious so I borrowed one —which happened to be a Nikon—and drove to New York City. I hung around St. Marks Place and kept bumping into Sid and Nancy over the next week. I was always trying to get him to swap his trademark cock ring belt with me. Every time I saw him I'd pull on one of the rings and he'd nearly fall over because he was so off balance. It was September 29, 1978 and Sid was in the middle of a three-day gig at Max's Kansas City. I photographed him at the show. There were two shows on each of those three nights. In between the shows I hung out front with Sid while Nancy constantly complained and tried to pull Sid away. She didn't like him having

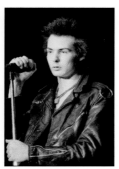

any fun without her. Sid wanted us to come back to the Chelsea later that night for a party. Nancy got mad and stomped away. She walked off the curb right into the path of a taxi. I happened to be standing there and grabbed her out of the path of the skidding and screeching cab. Less than two weeks later, Sid was in jail for the murder of Nancy and he didn't even know if he did it or not.

About a year later I finally owned my own camera—which also happened to be a Nikon—and I started shooting everyone. Every band and every show that I went to... and I went to a lot. It was pure fun. Fun-fun-fun! Tons of fun. I walked into dressing rooms like the reporter on the scene

that I was and photographed people like I knew them. I was never chased away; in fact I was mostly encouraged and usually welcomed. I had my eye on the future and wanted to document this entire punk era so that I could look back on it years later. I knew we looked good with all the spiky hair, make-up, leather and graphics—and I was curious what we'd all think about it in the future. I forever had my camera in hand and I went on a mission.

These shows were never about violence. They were about being goofy and having fun. They were about doing things for yourself if you weren't satisfied with what was out there. They were empowering.

Anarchy and Freedom was the motto. Boredom and Nowhere was the image.

If you didn't like popular music—create your own.
If you didn't like current fashions—make your own clothes.
If you didn't like accepted rules—use your brain to generate new ones.

Lots of creativity and energy in abundance is what it was all about. And I loved every minute of it!

Rikki Ercoli
San Francisco

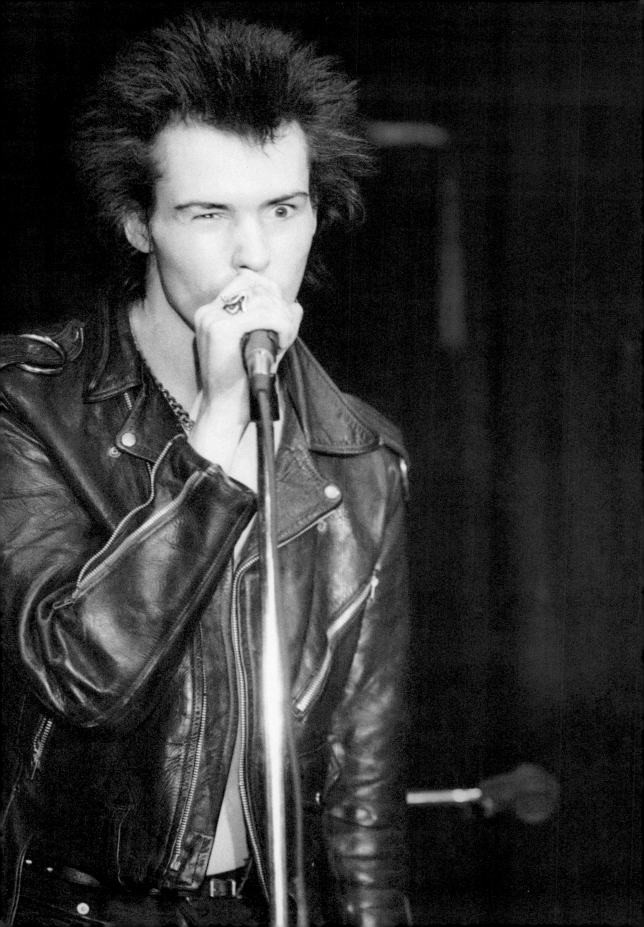

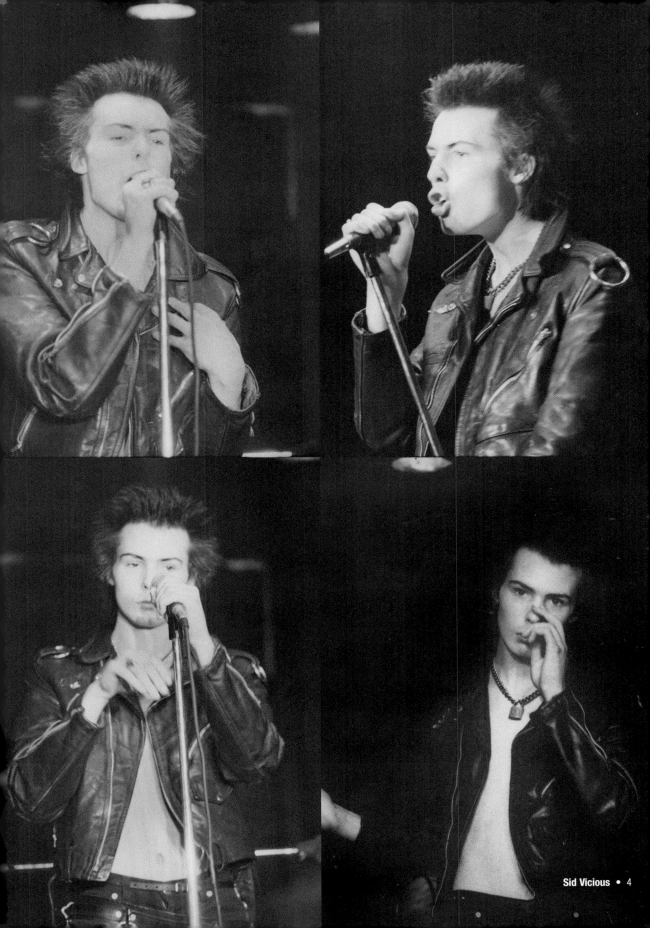

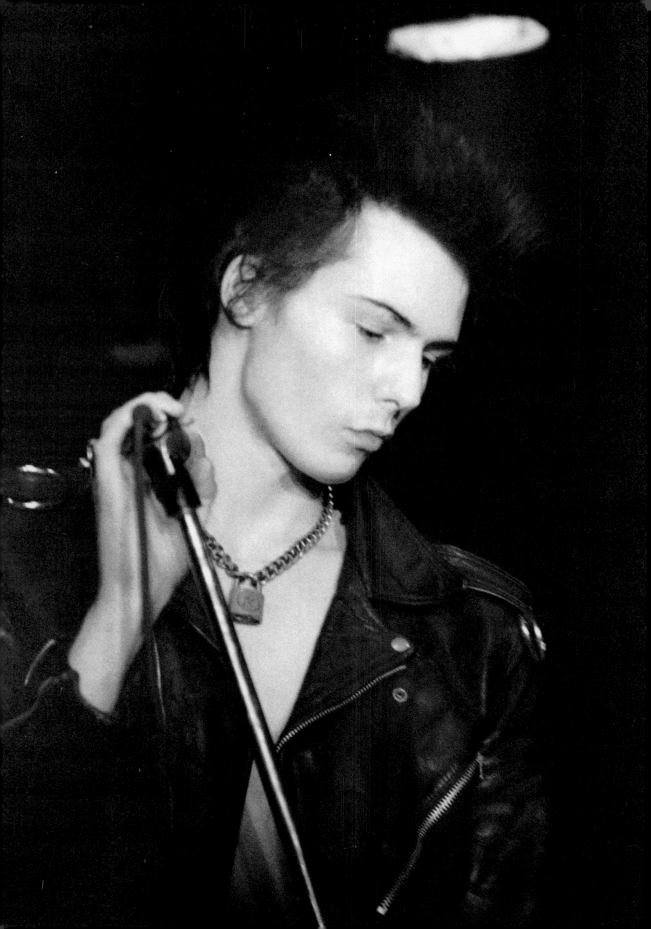

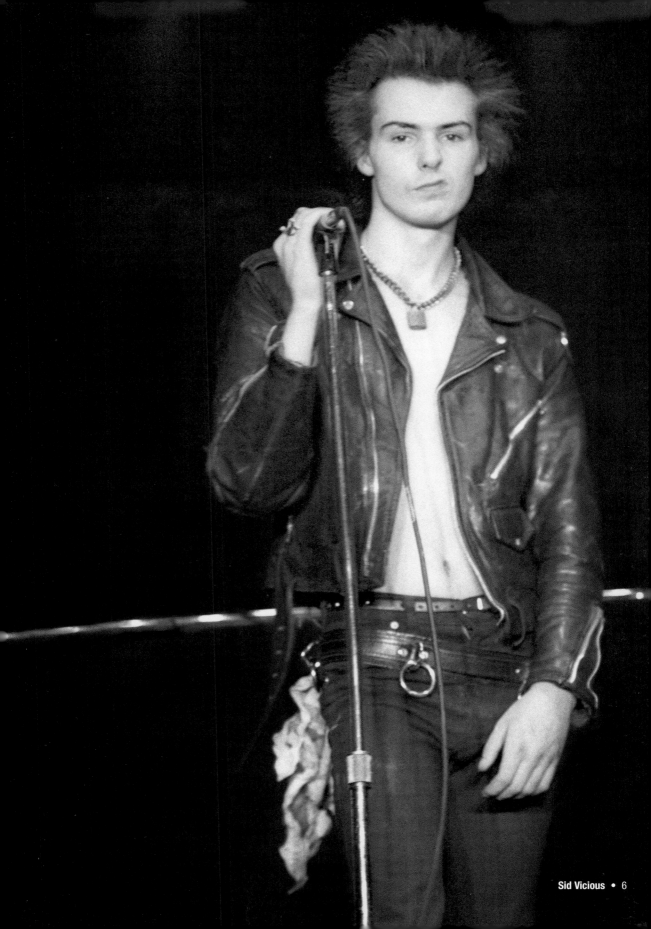

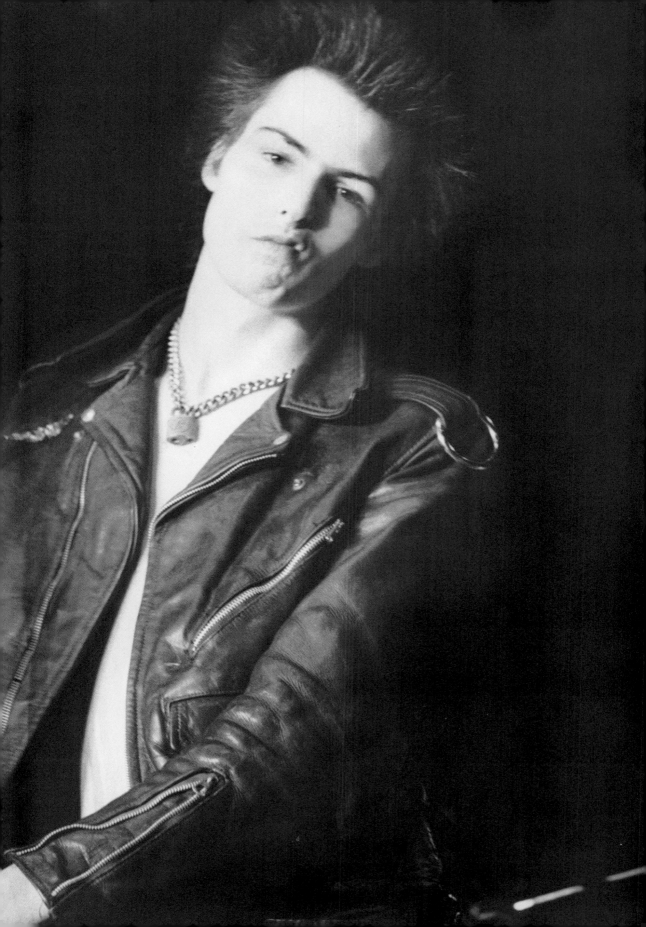

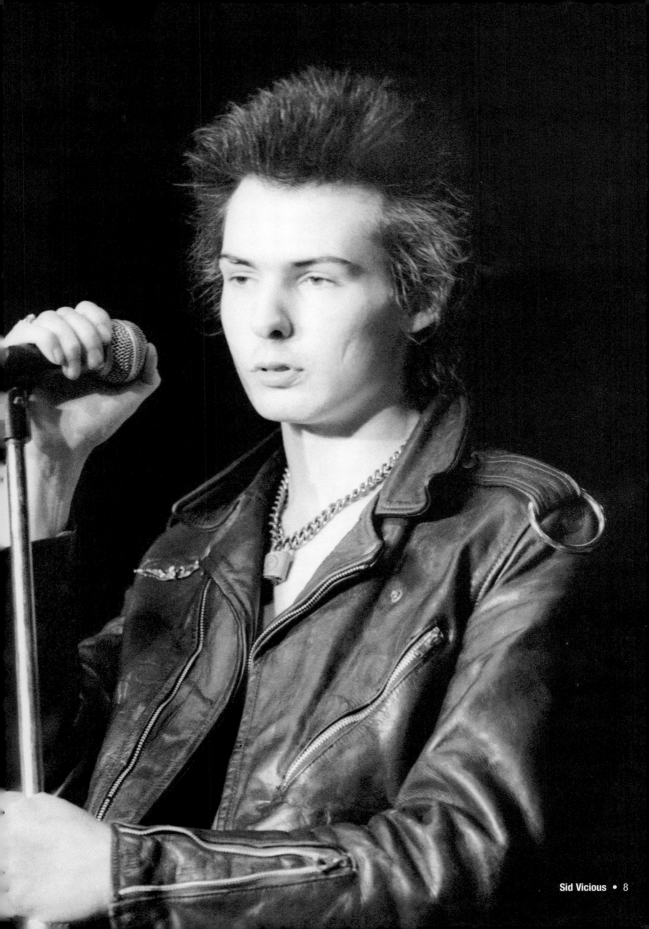

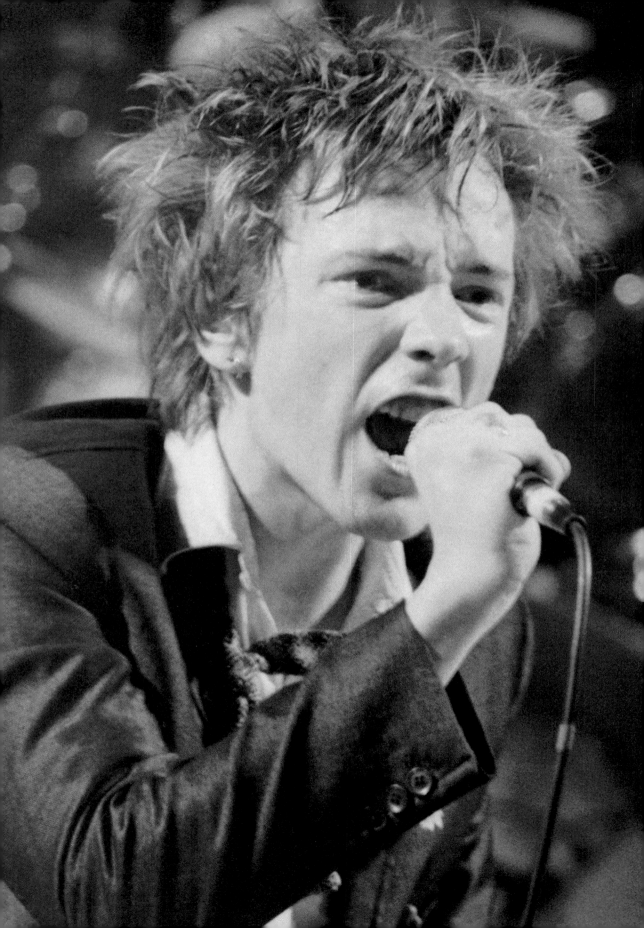

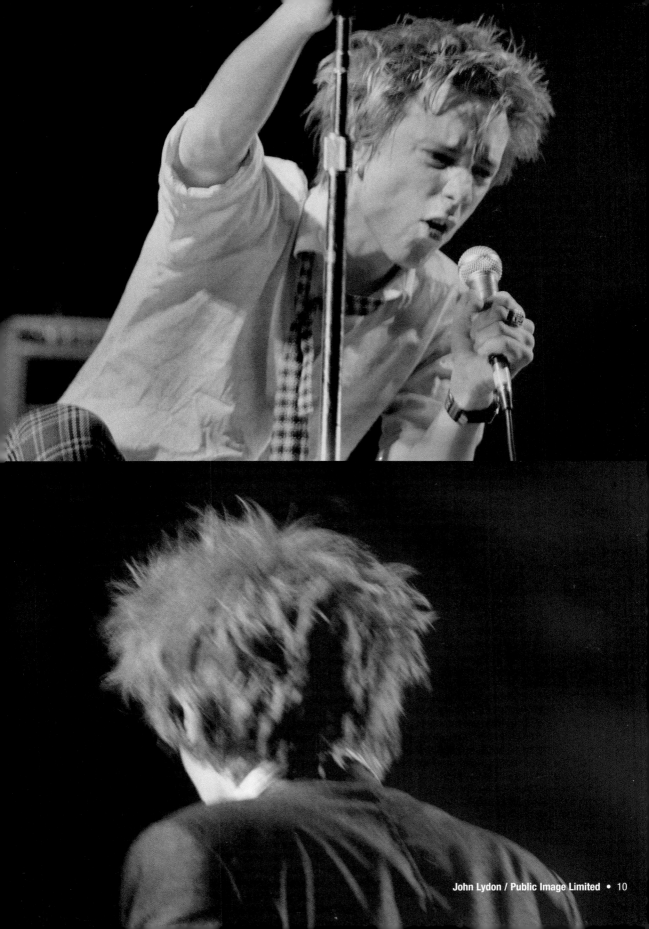

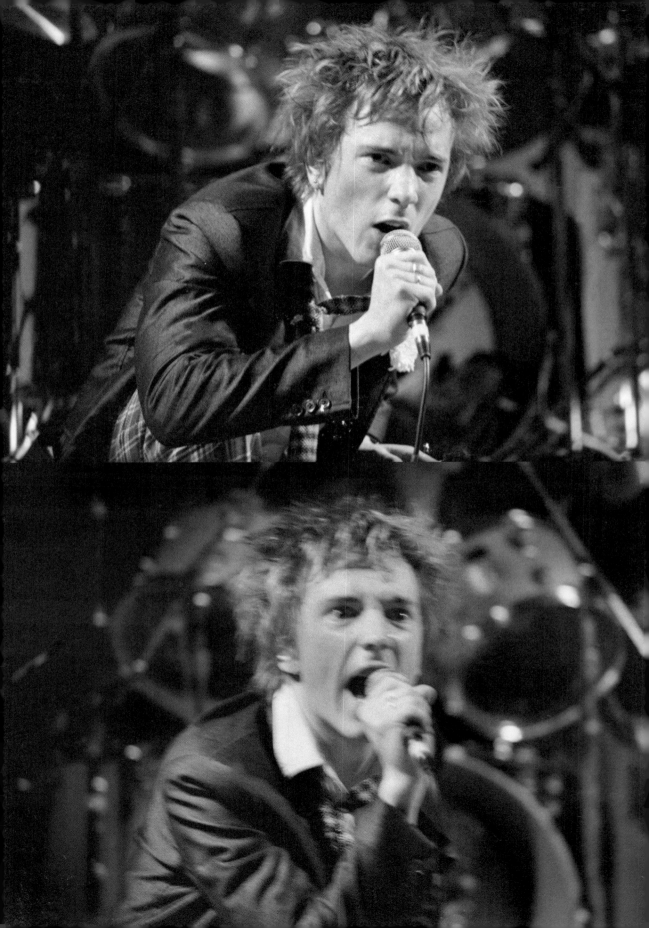

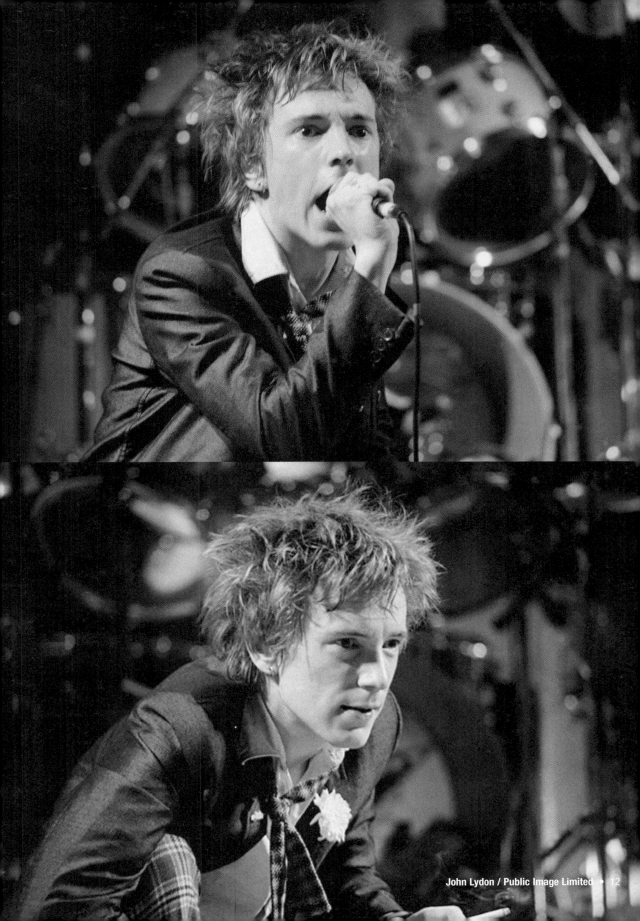

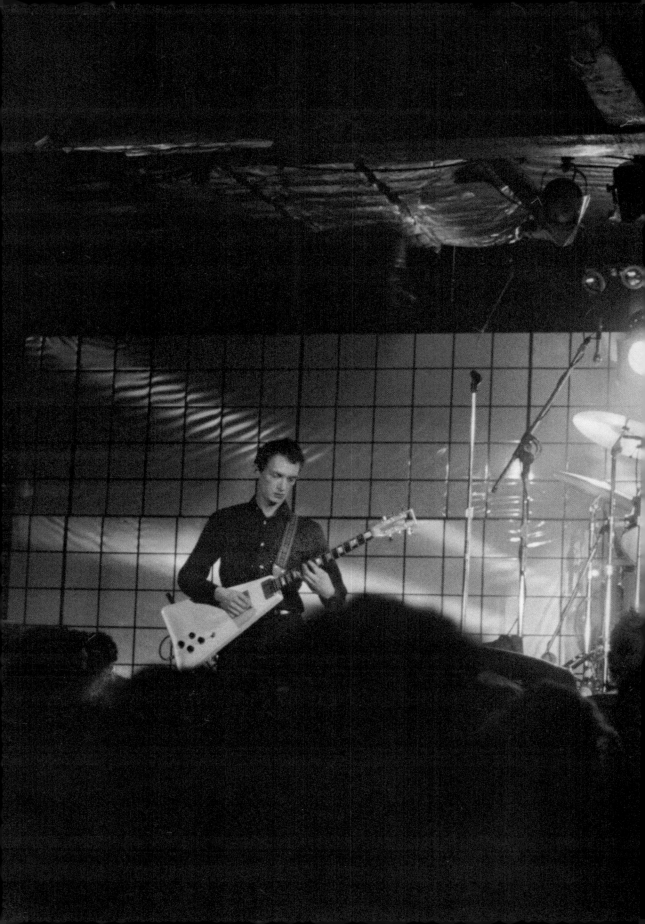

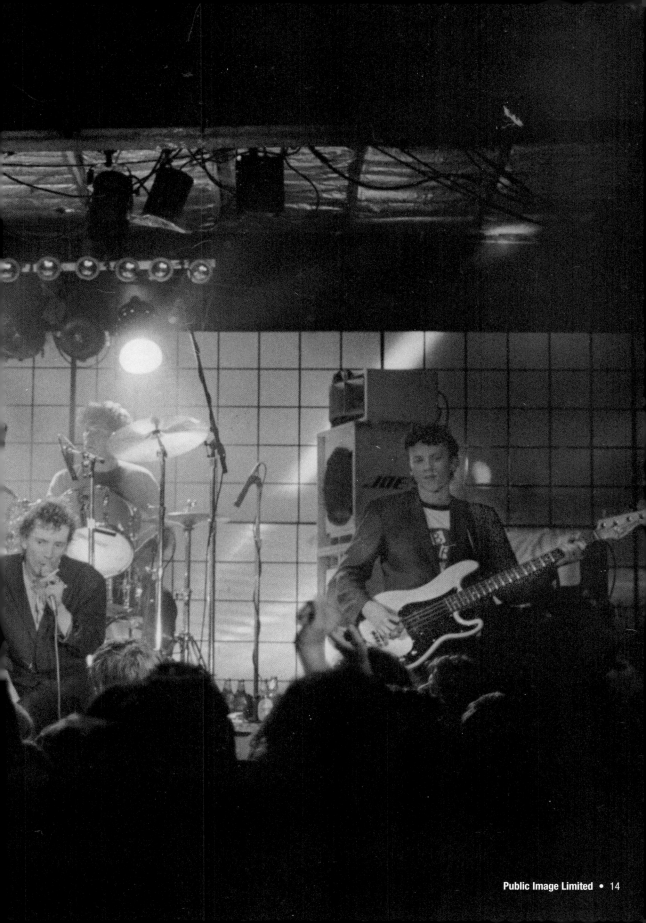

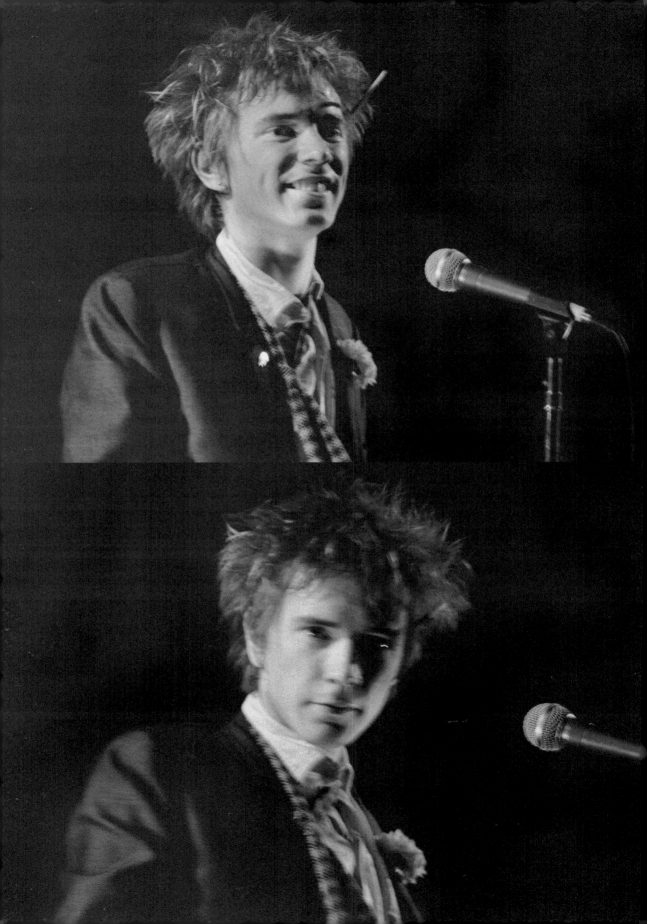

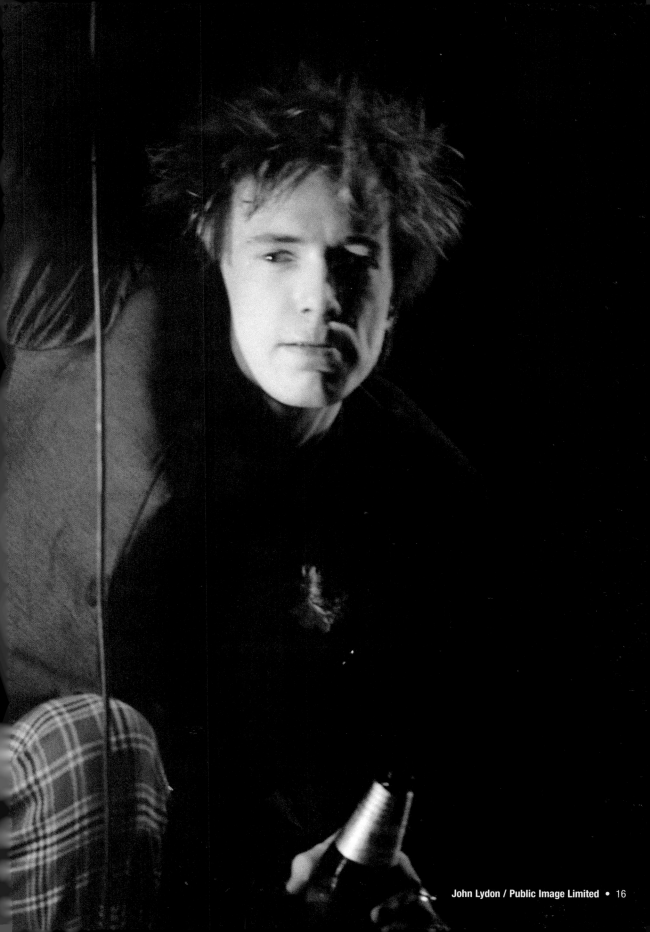

John Lydon / Public Image Limited • 16

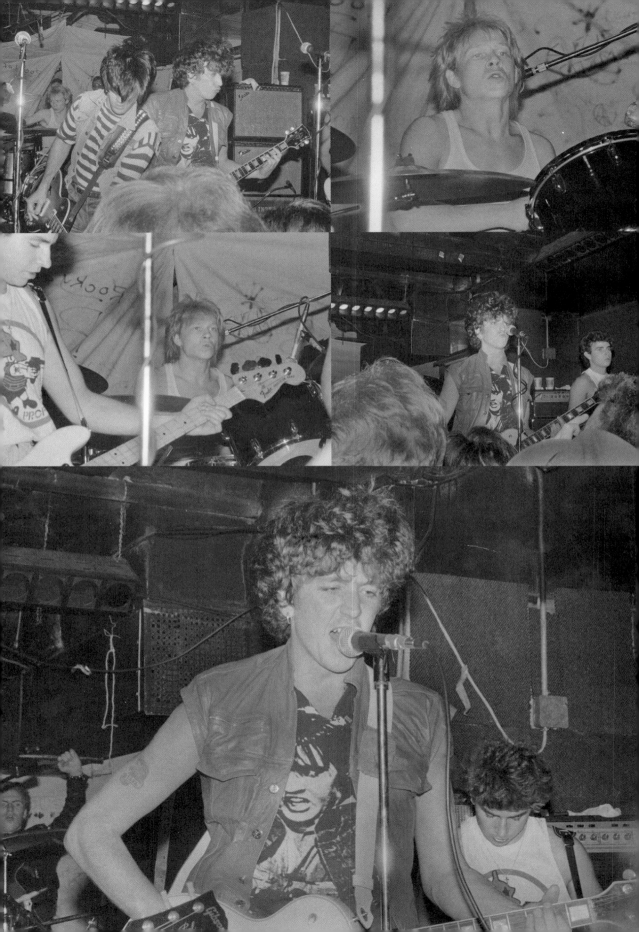

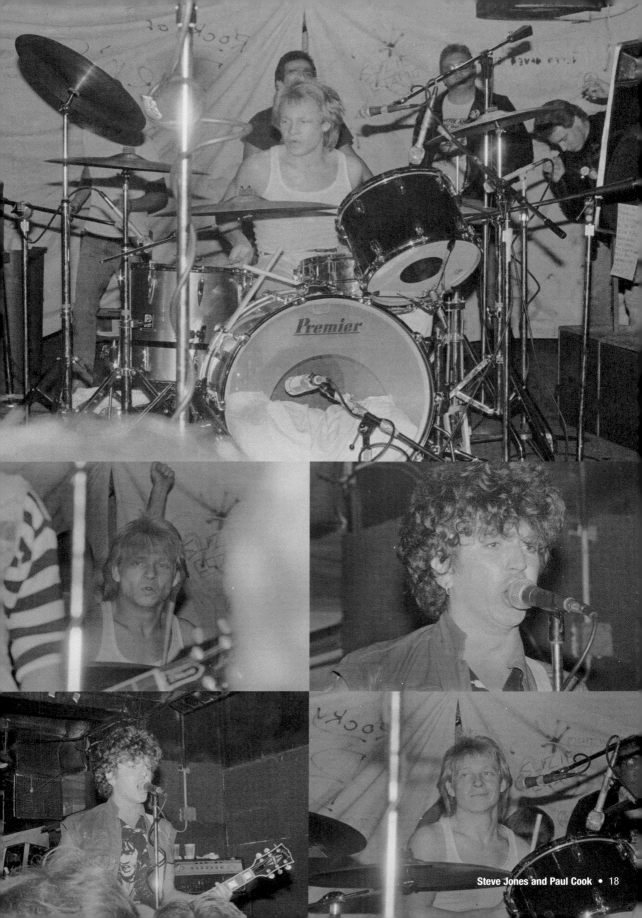

Steve Jones and Paul Cook • 18

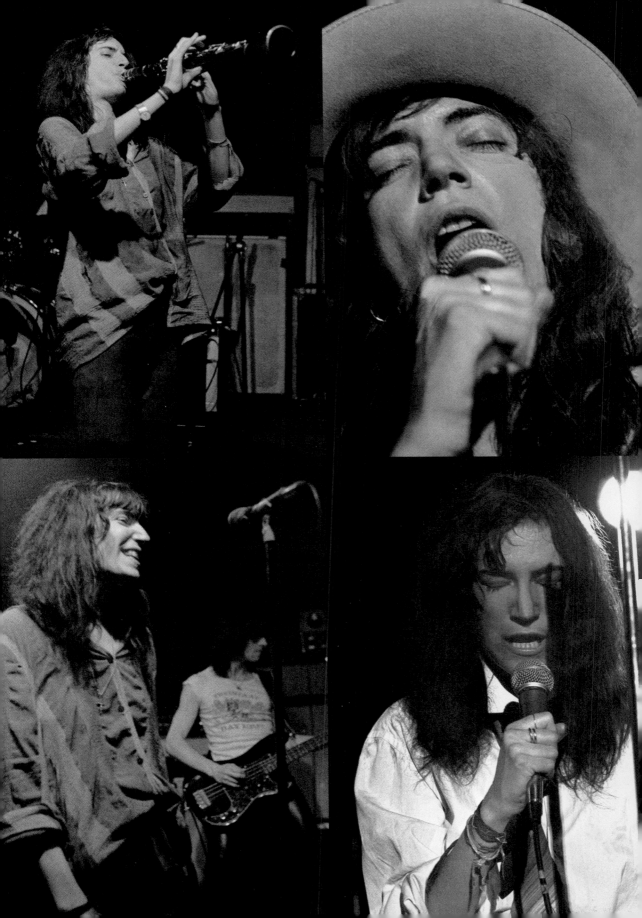

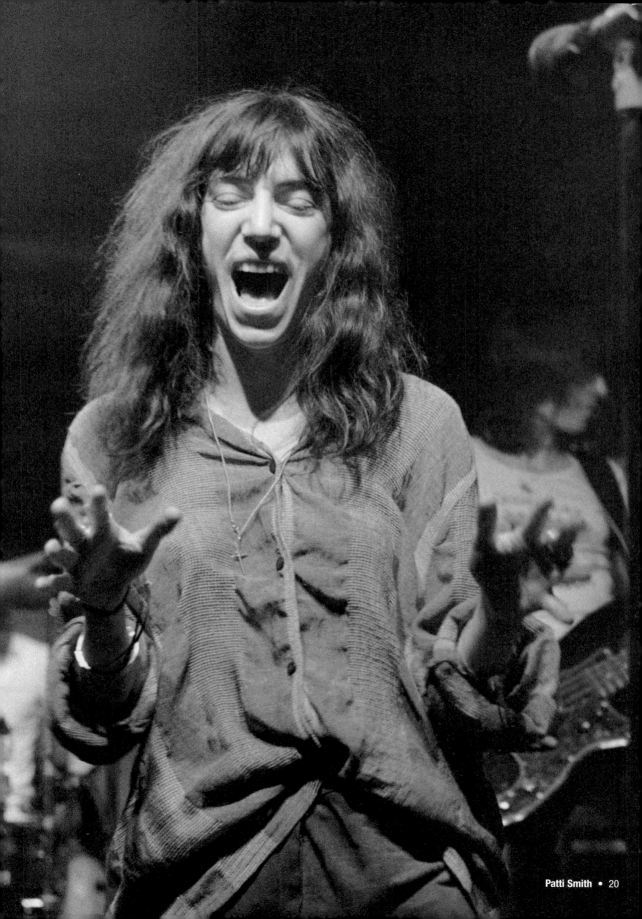

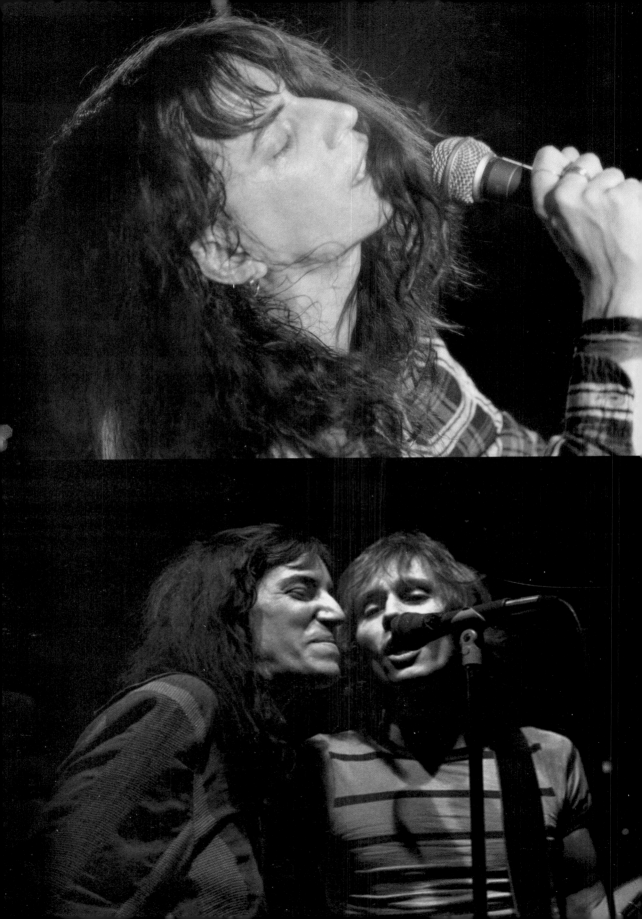

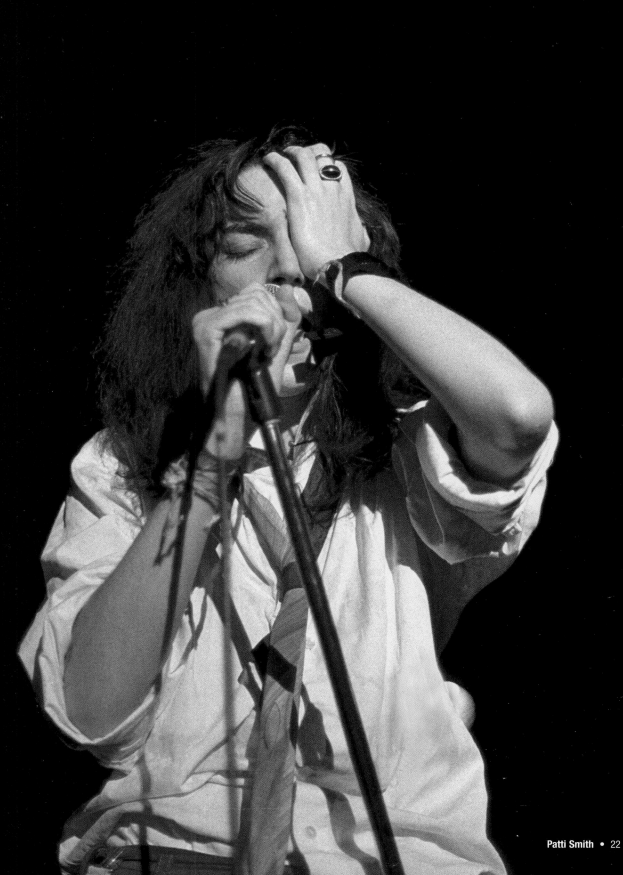

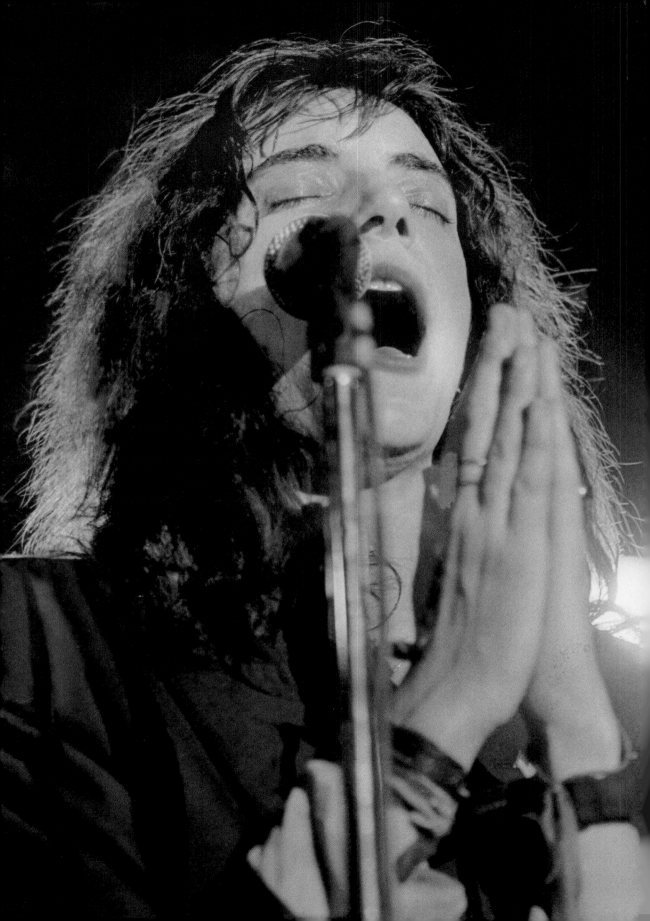

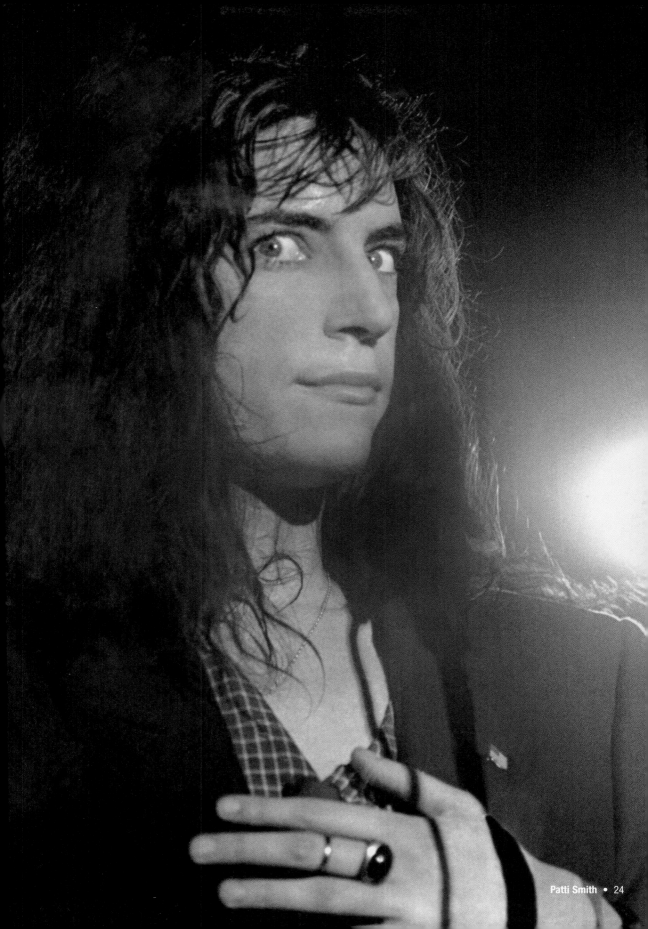

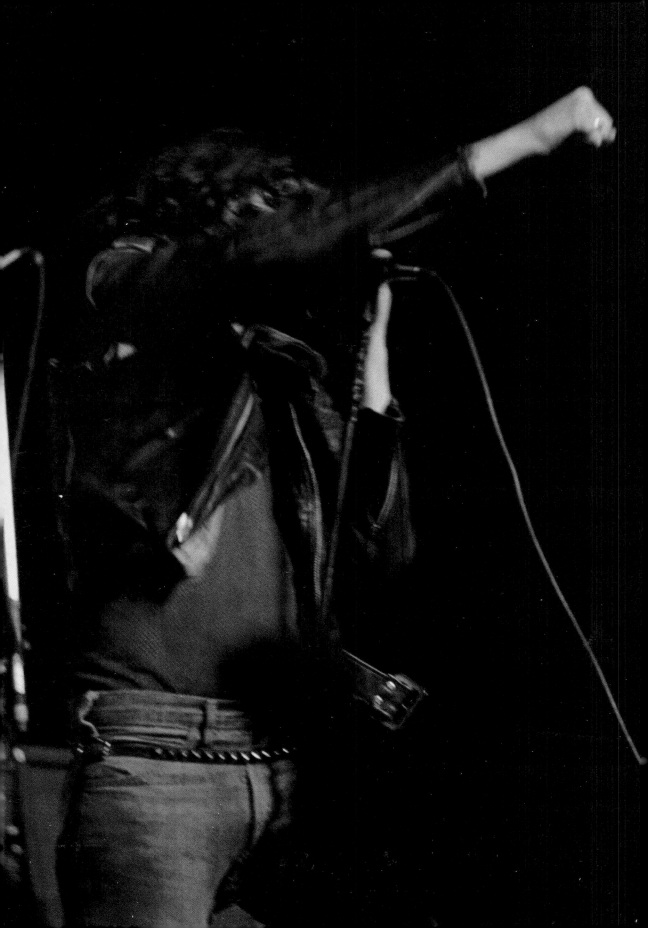

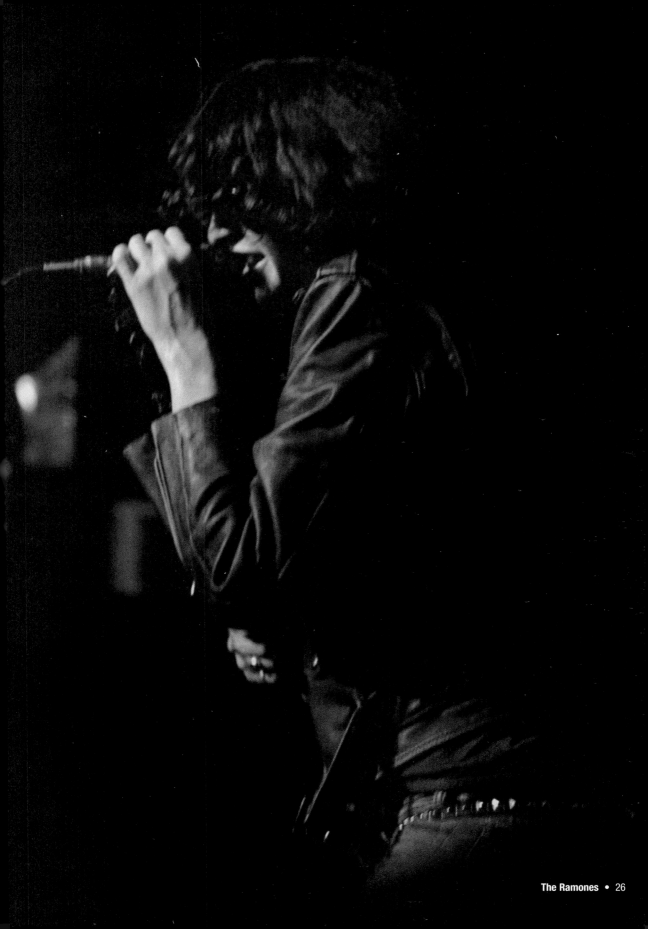

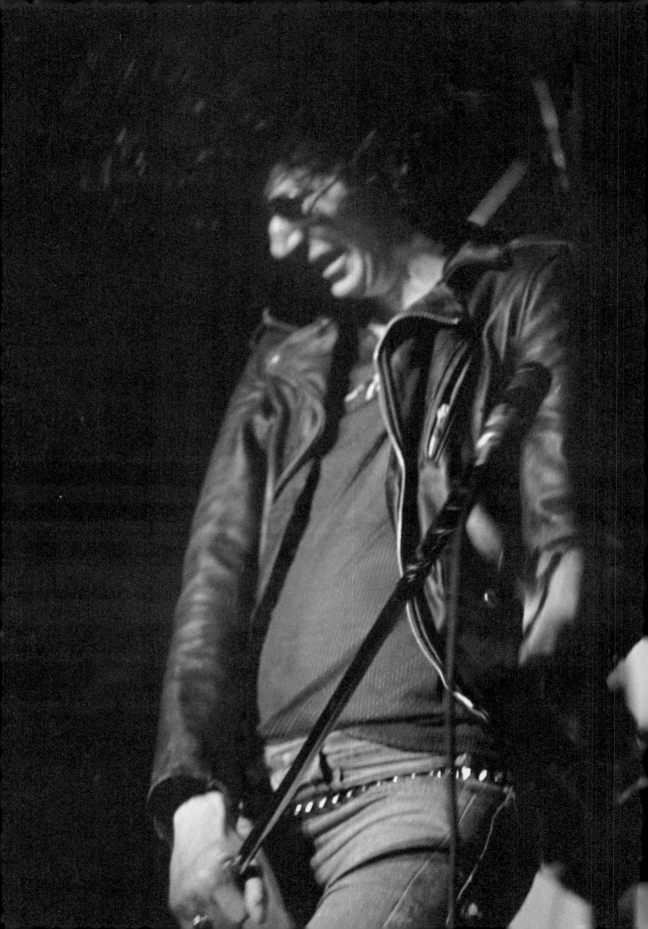

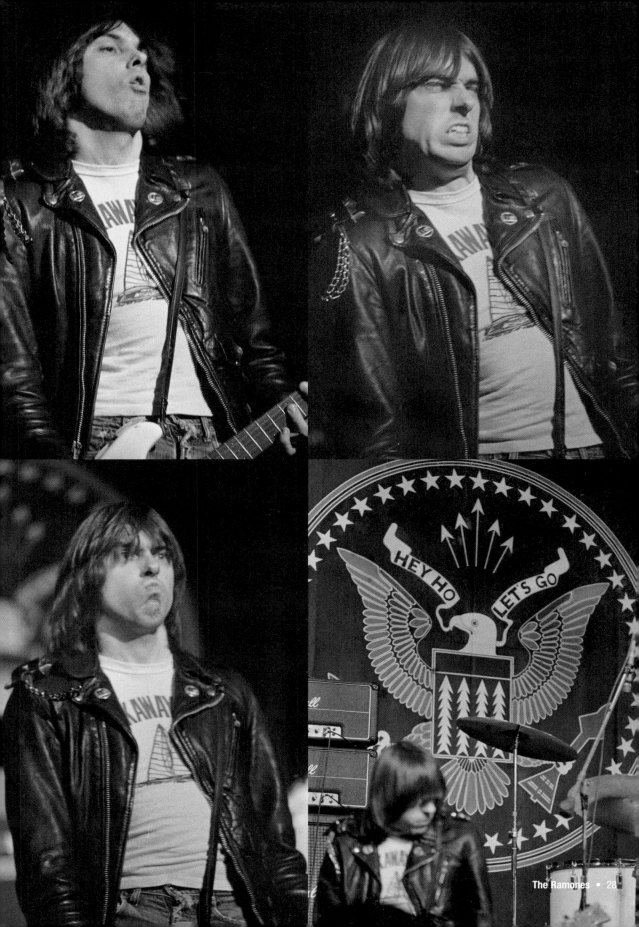

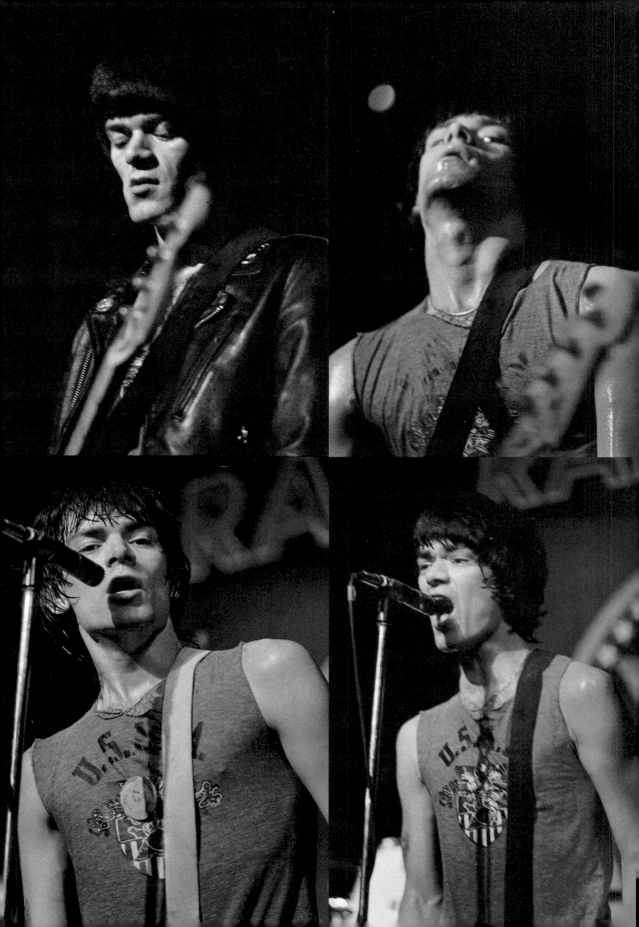

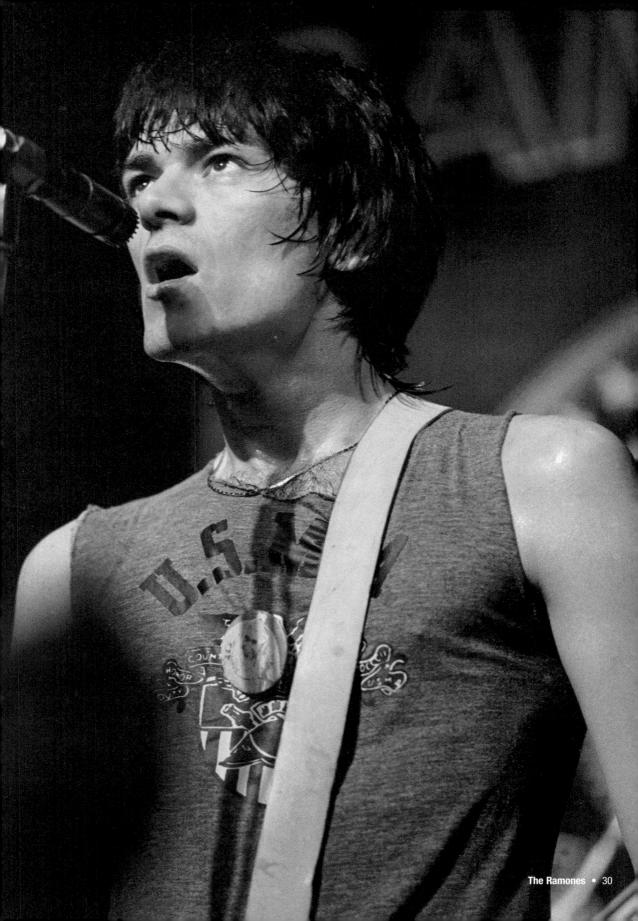

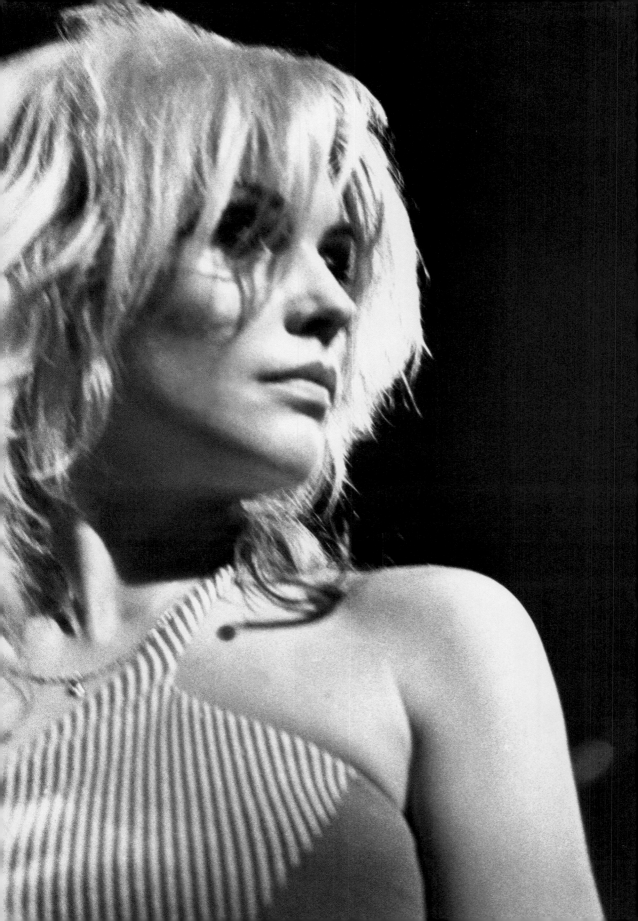

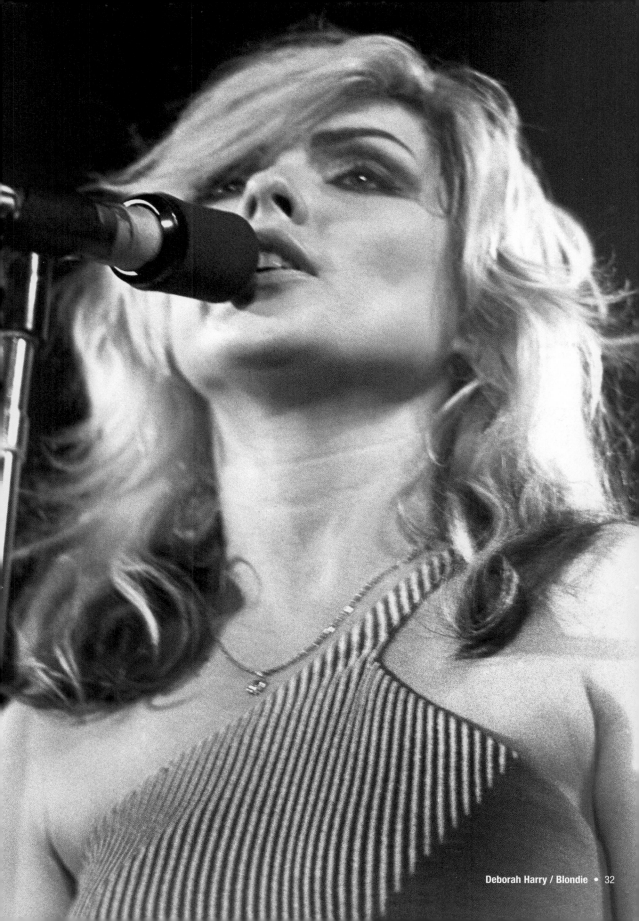

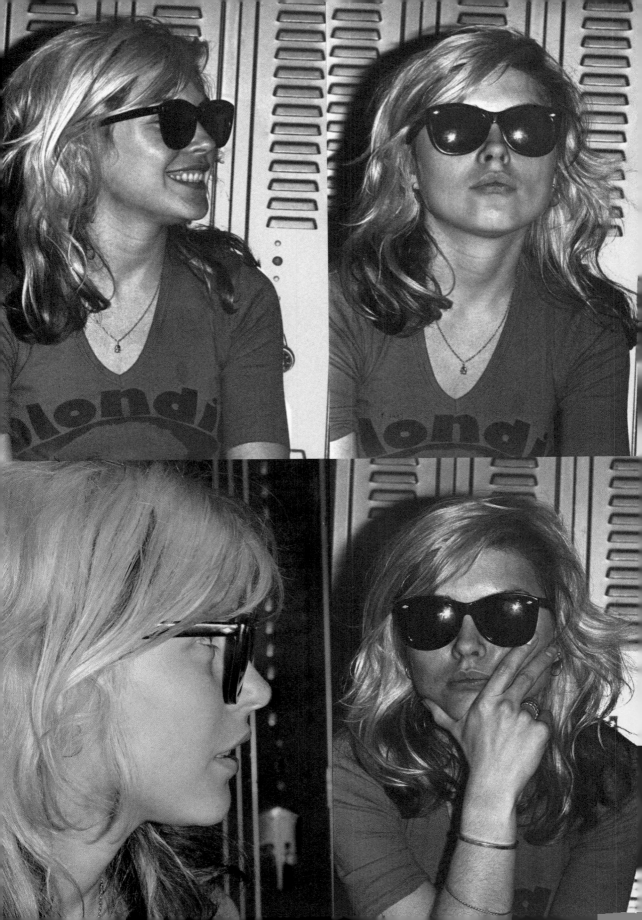

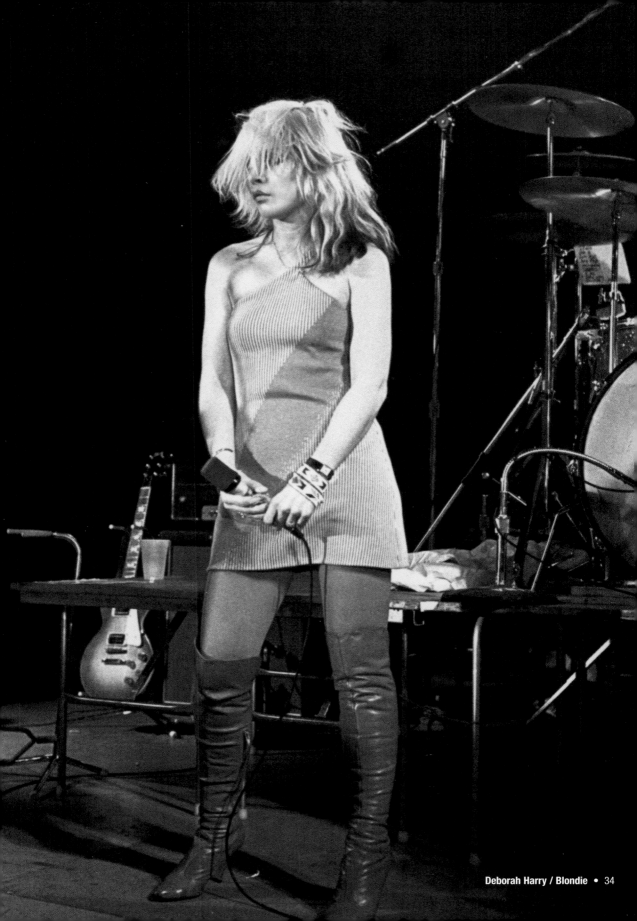

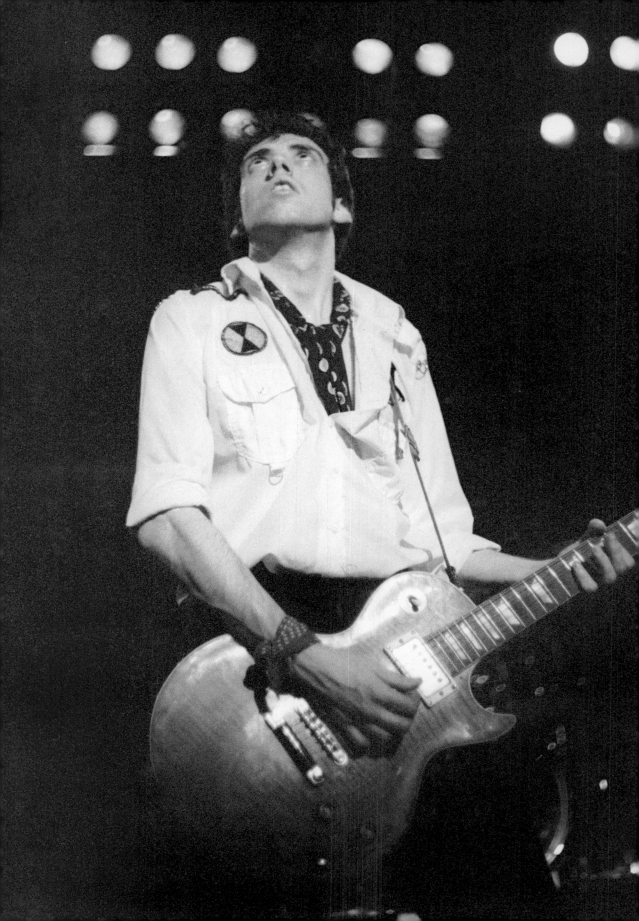

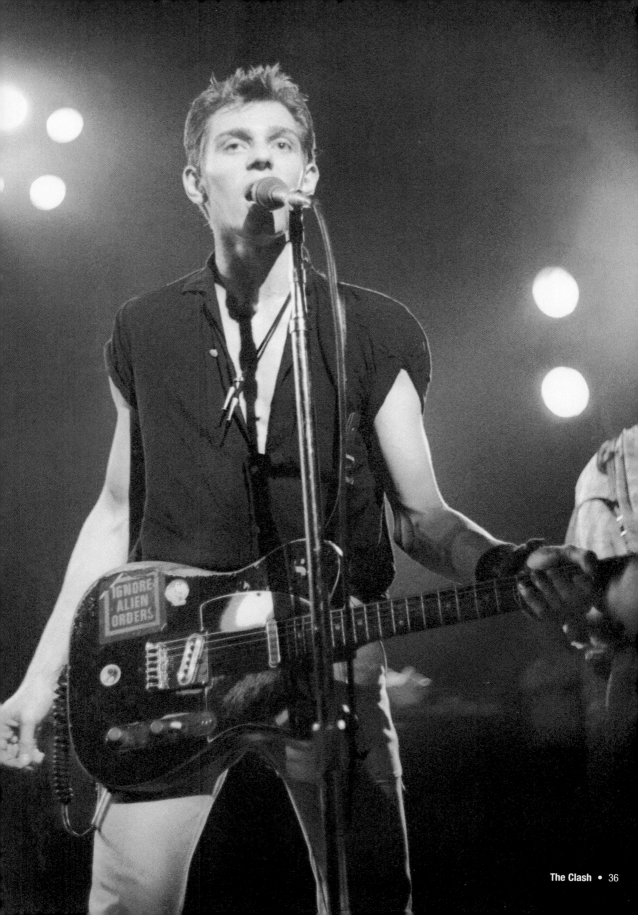

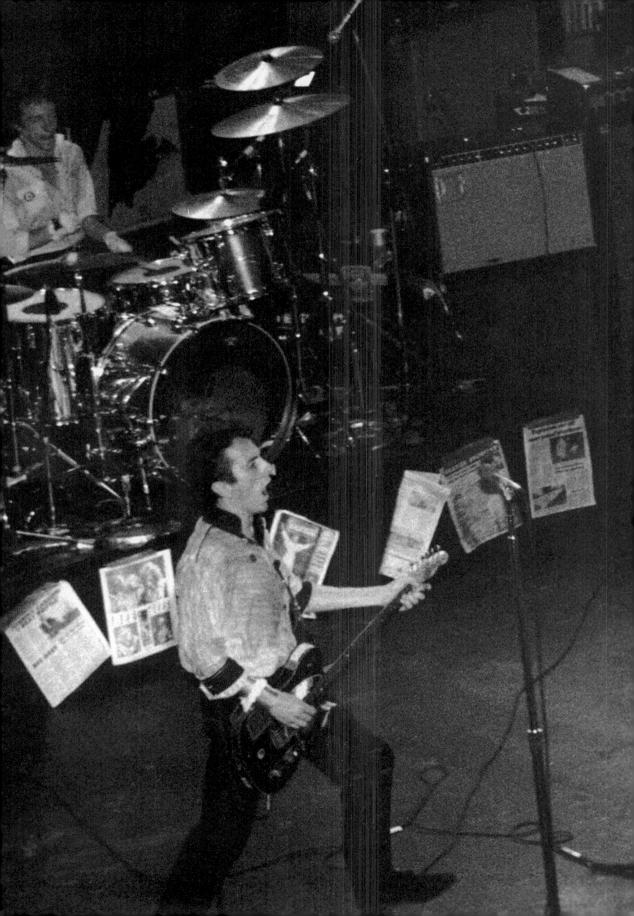

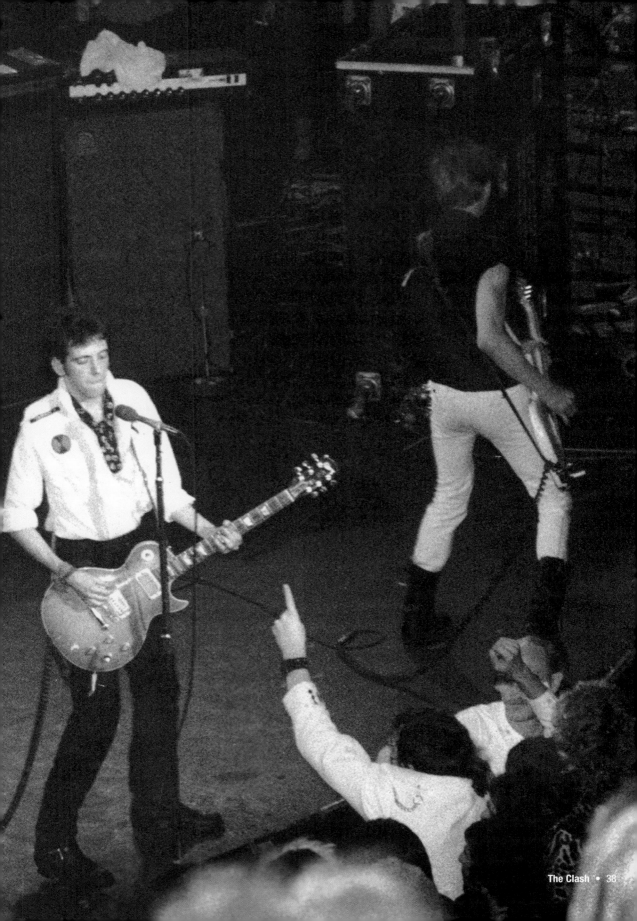

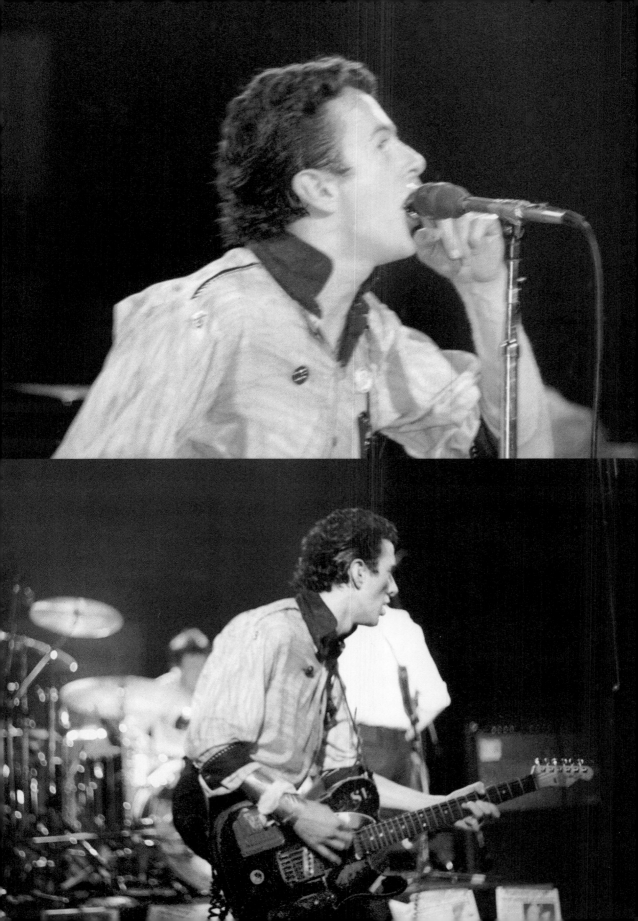

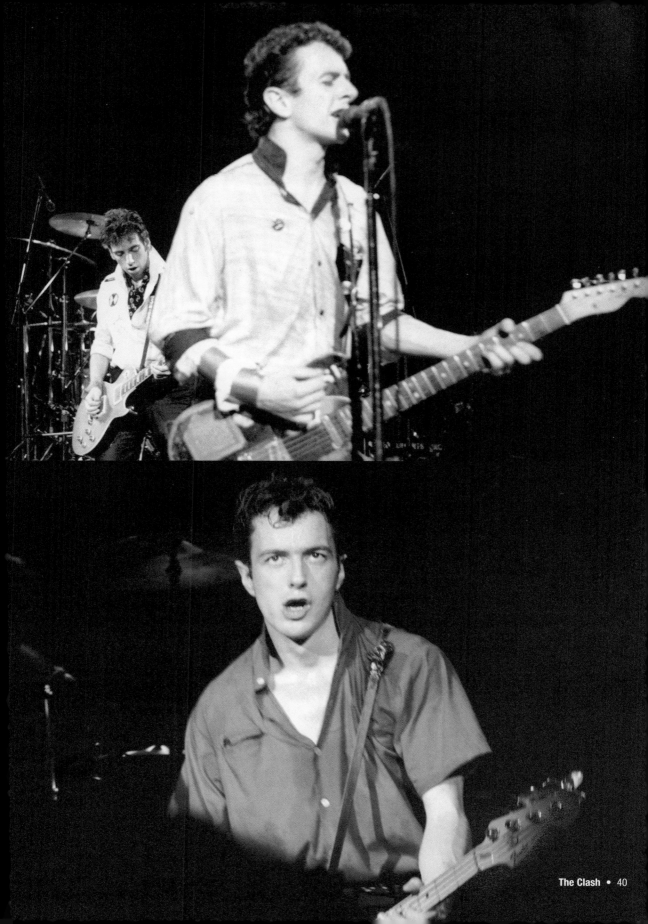

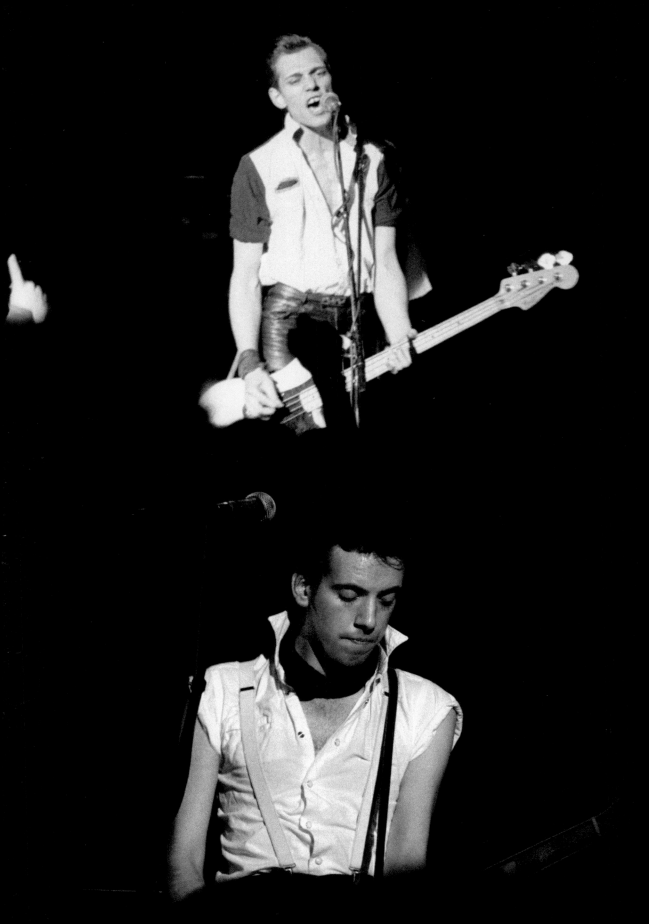

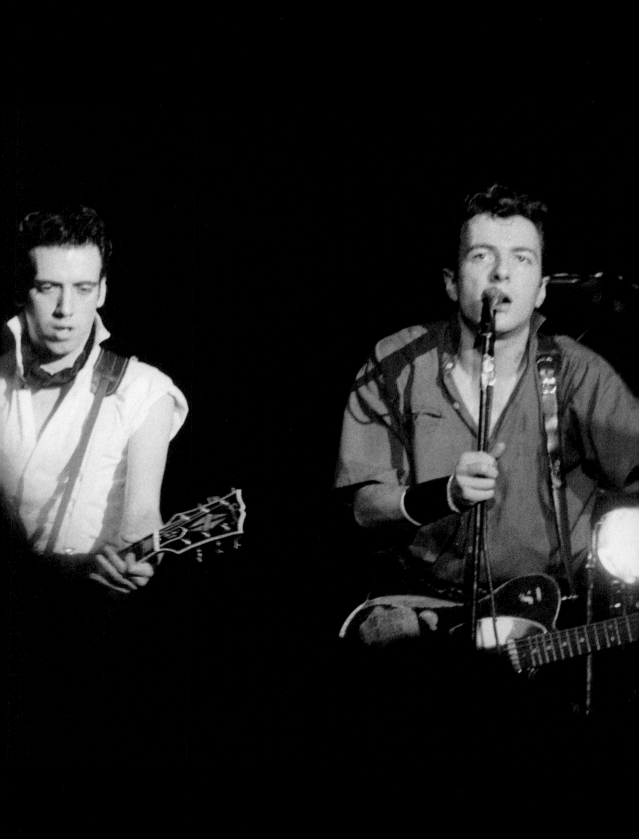

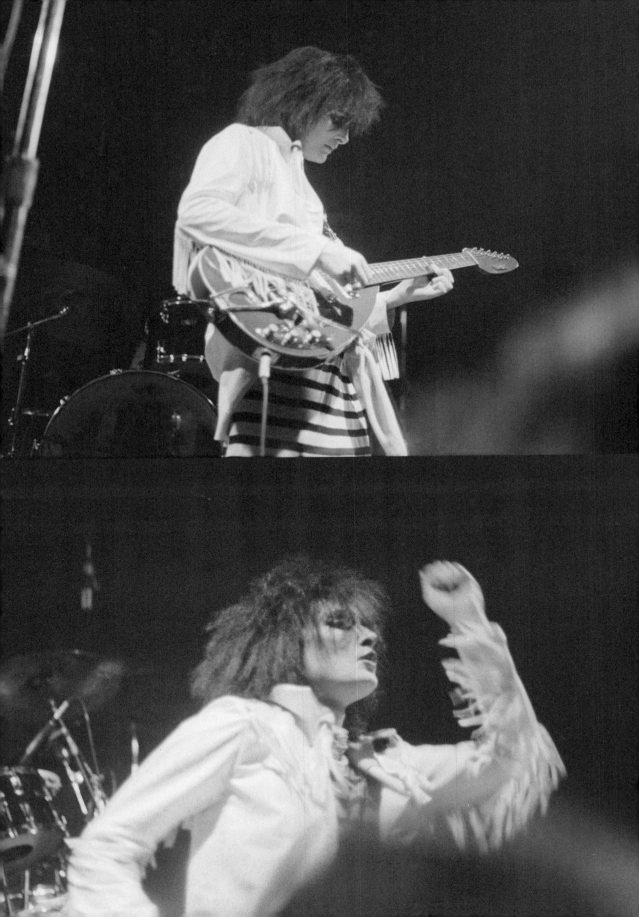

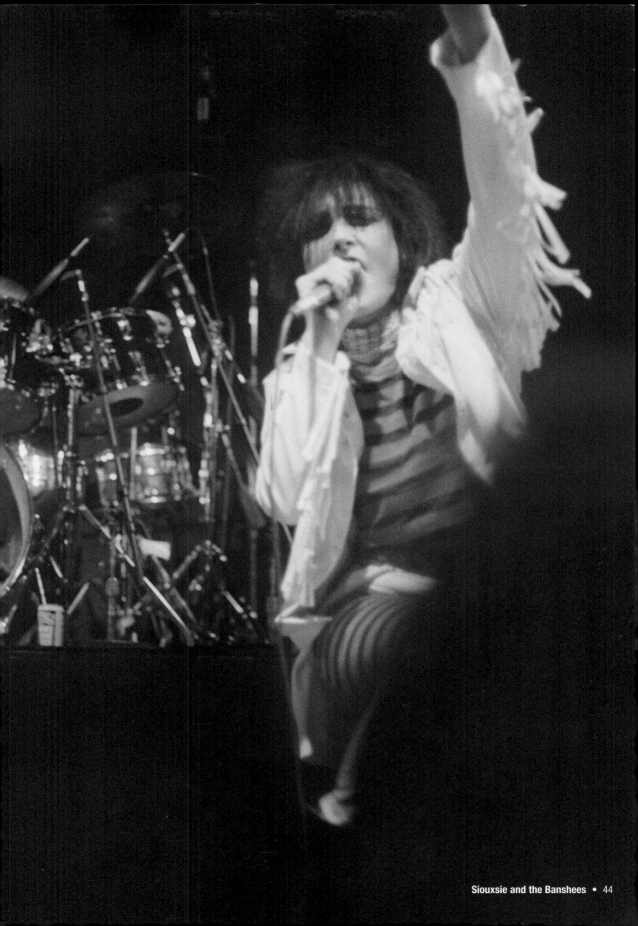

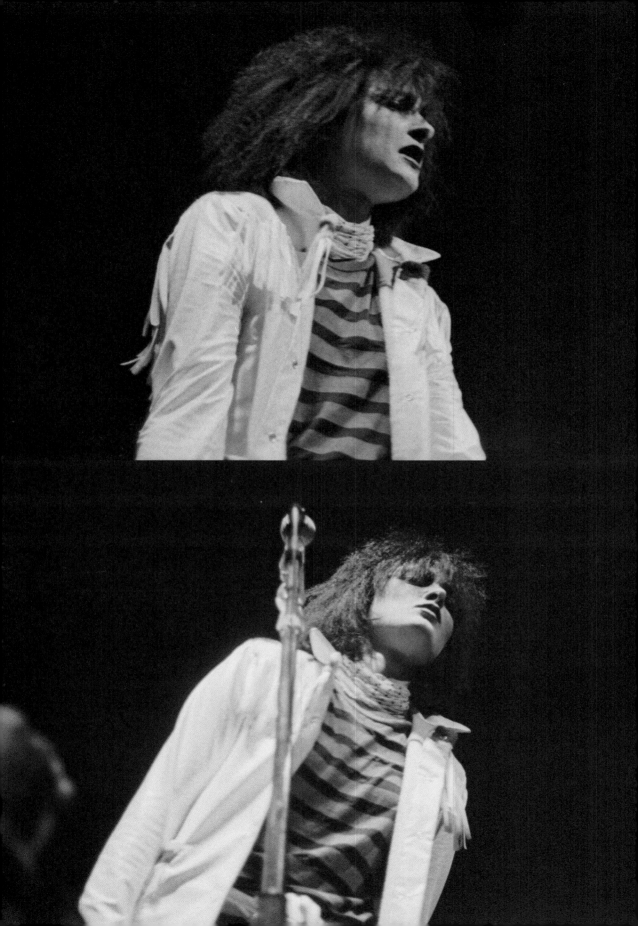

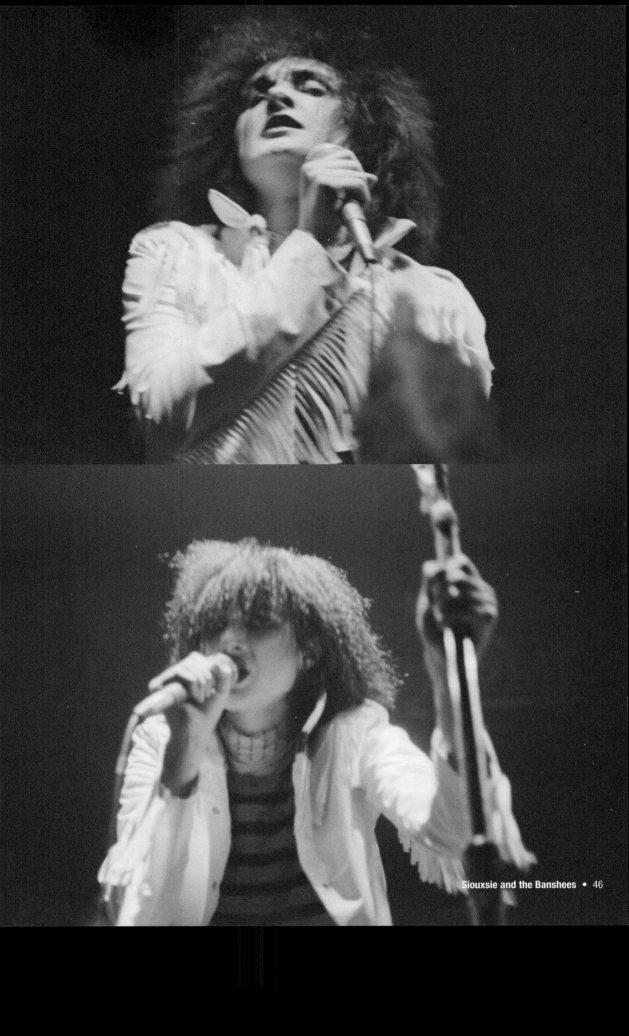

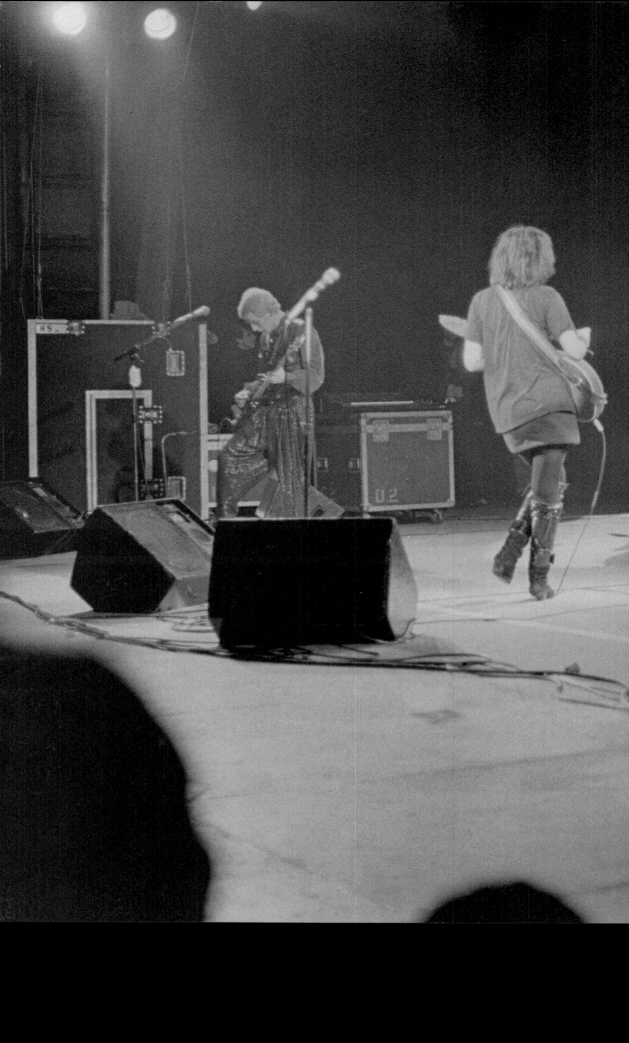

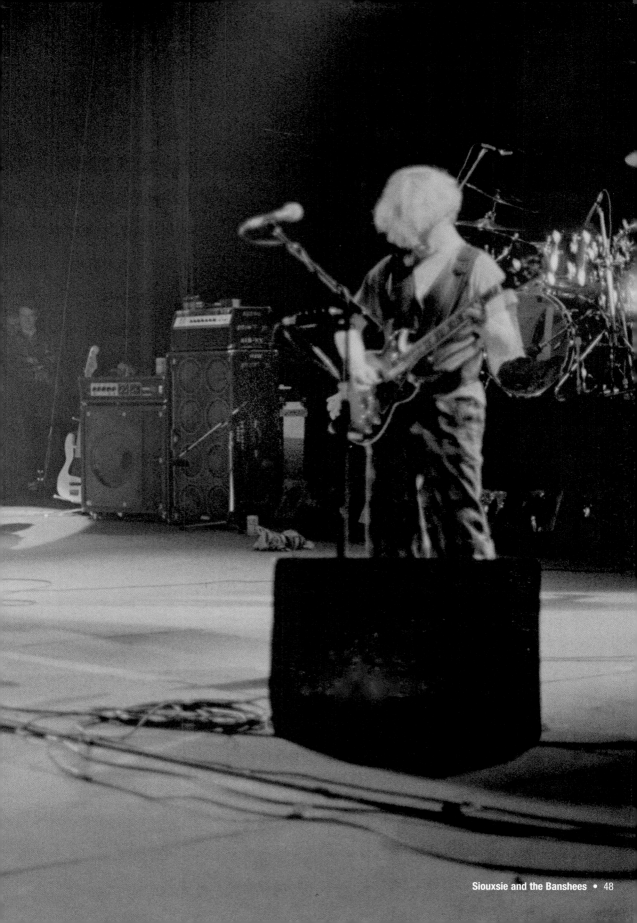

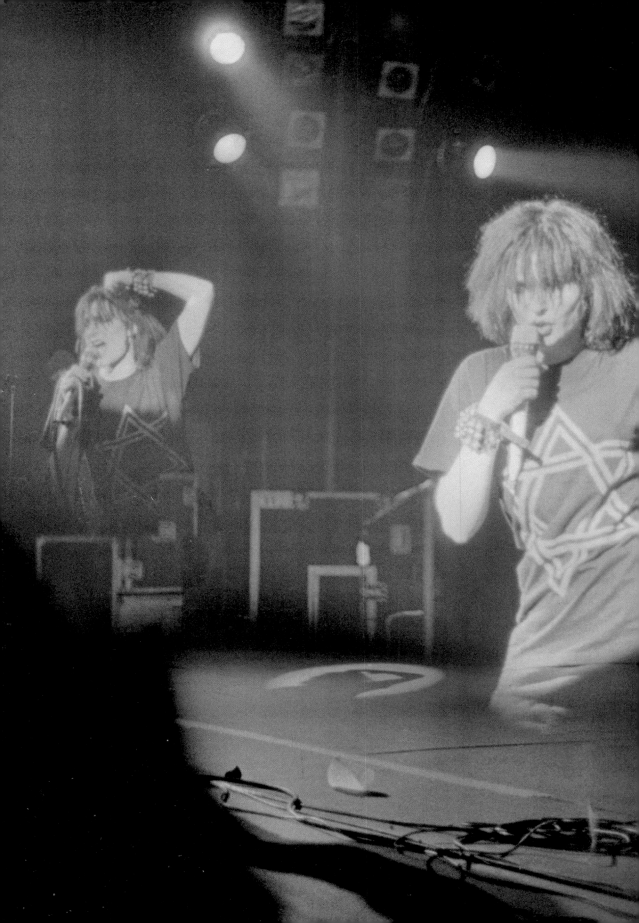

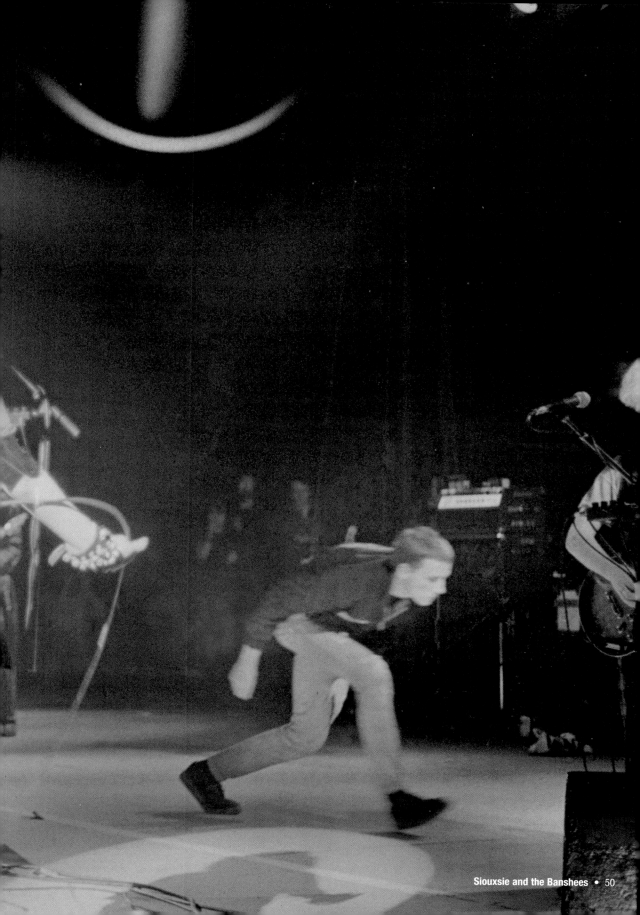

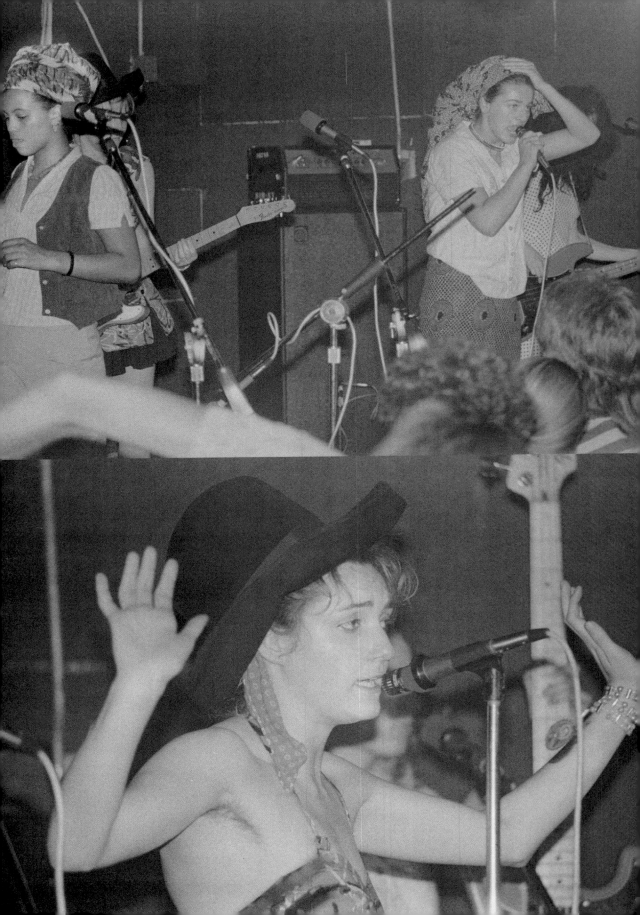

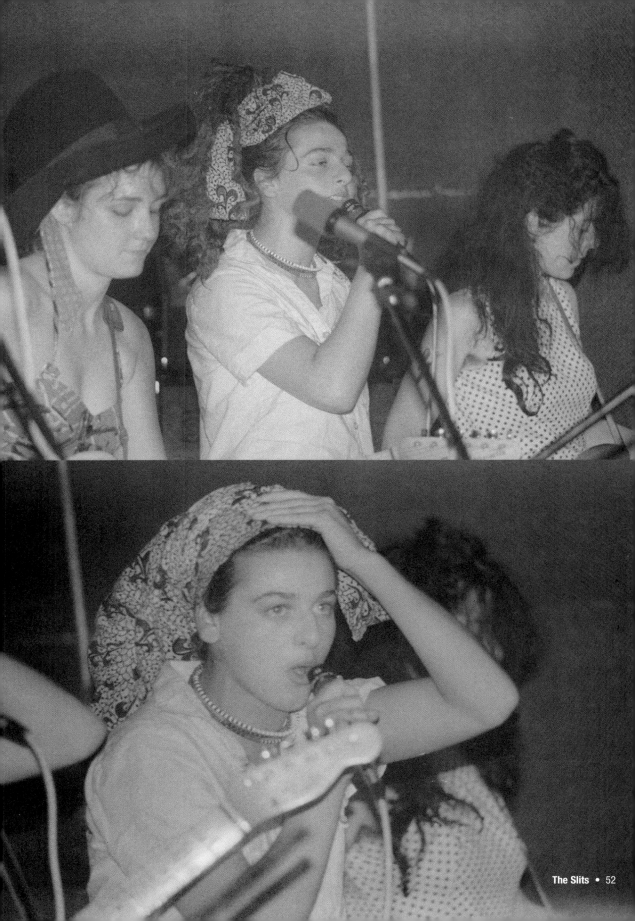

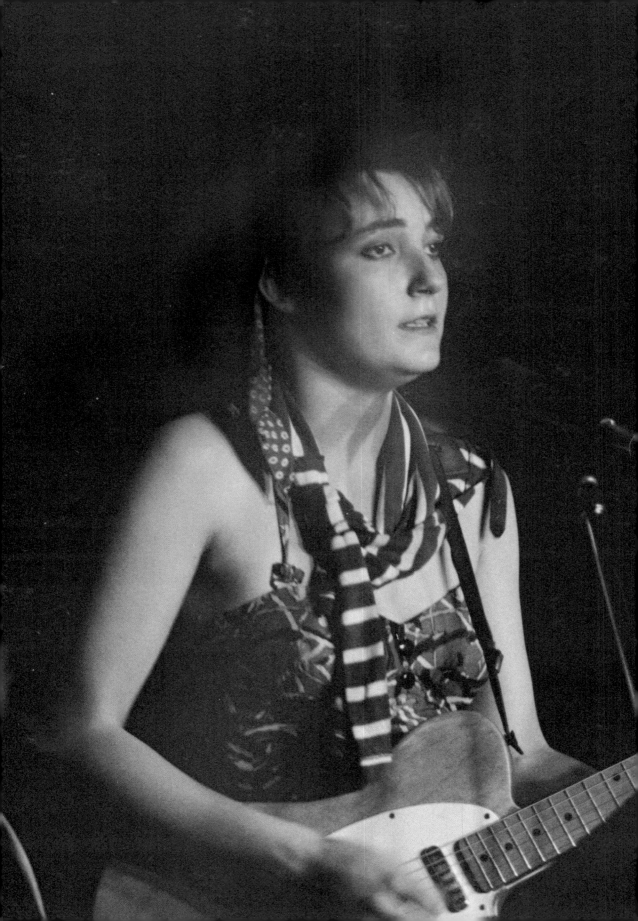

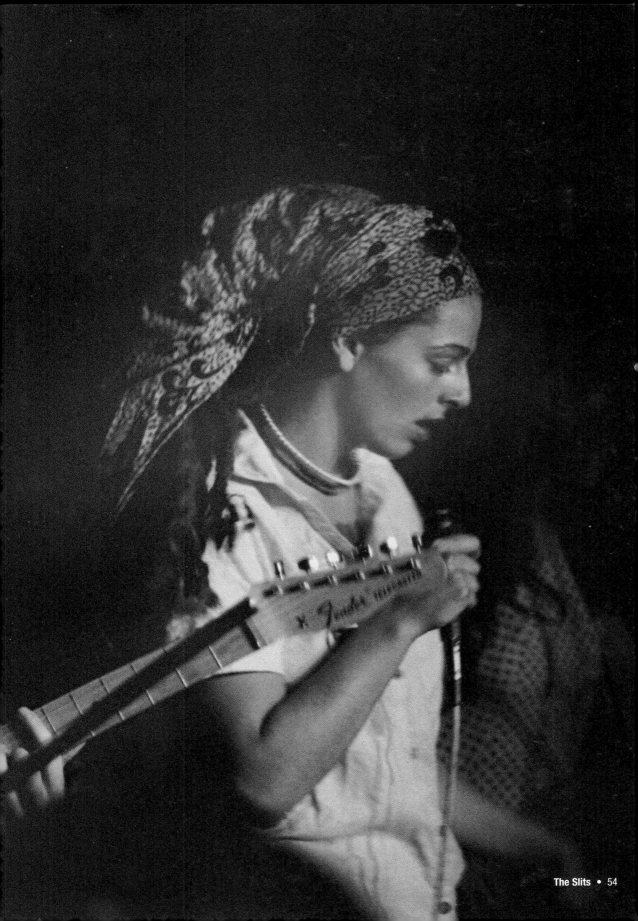

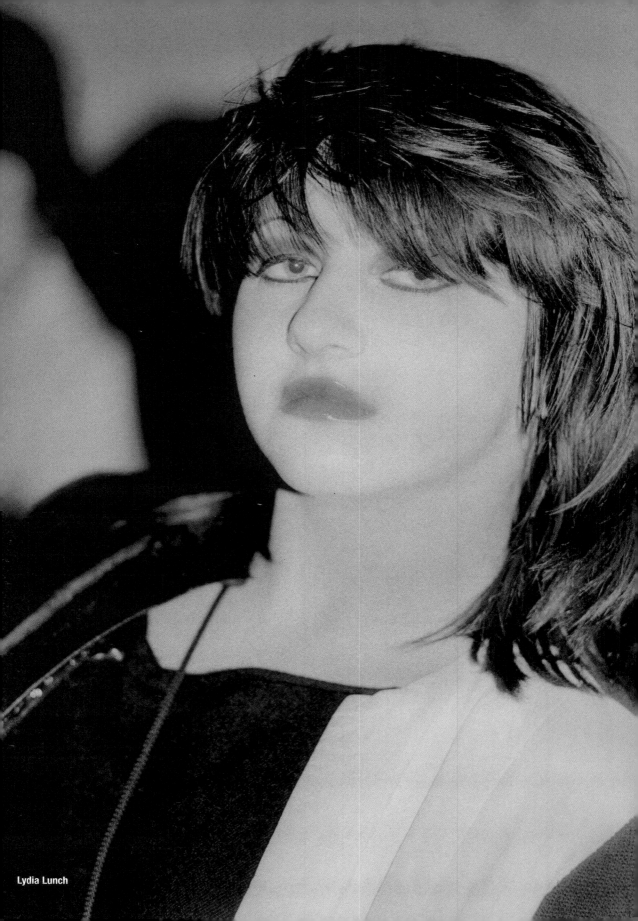

Lydia Lunch

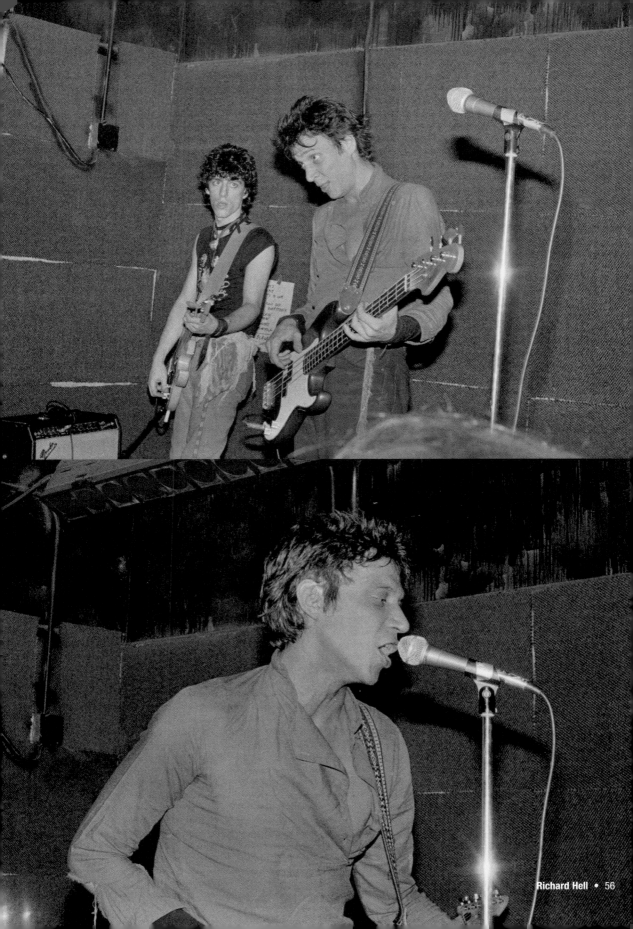

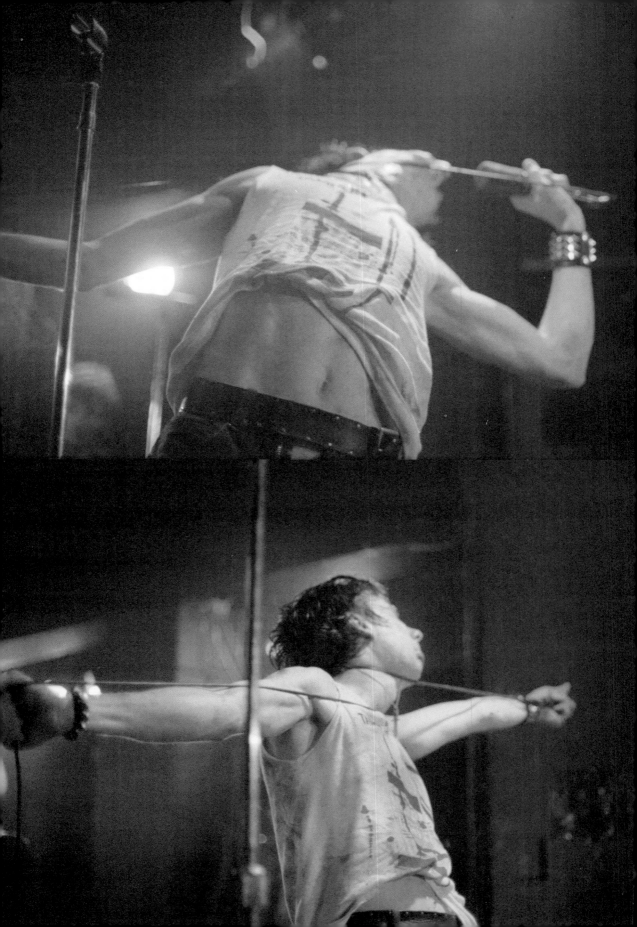

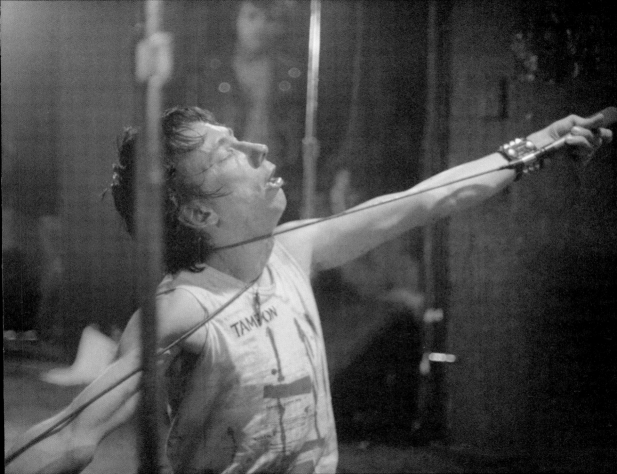

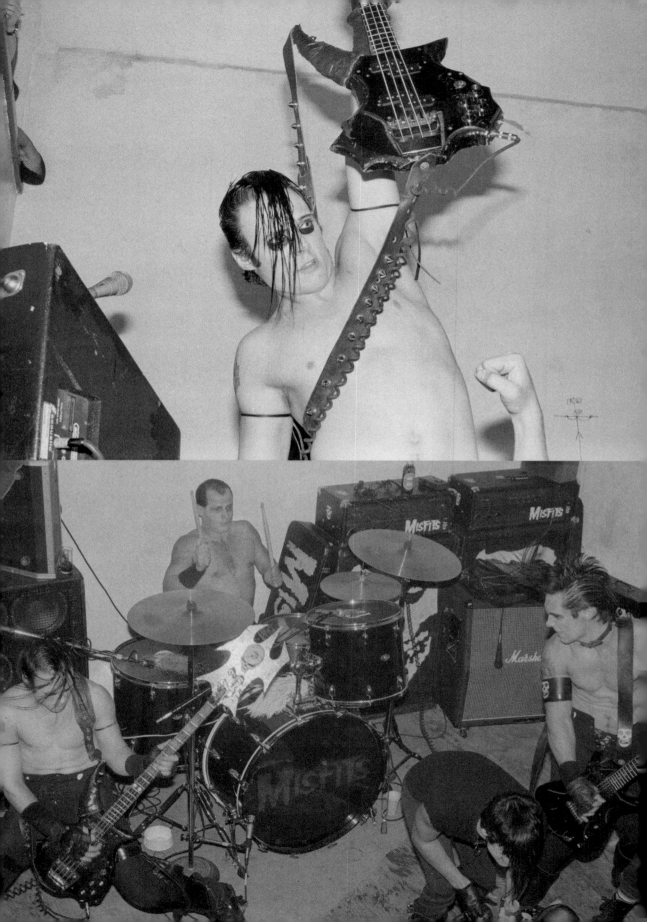

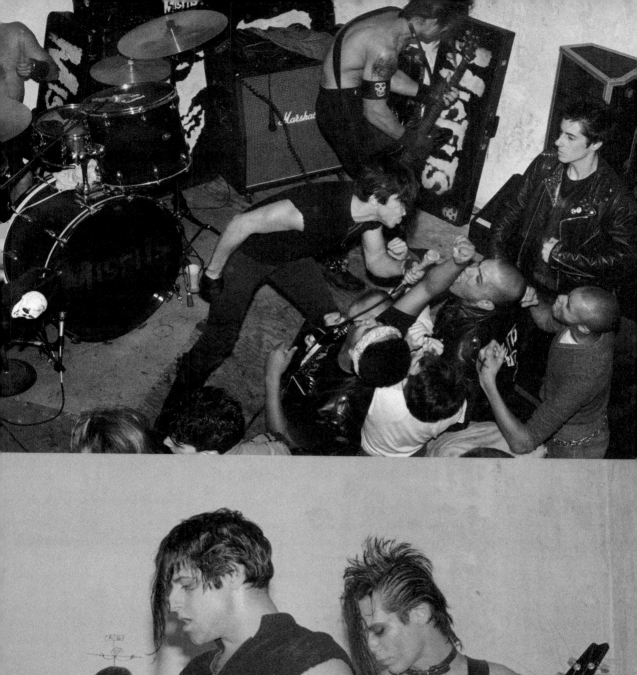

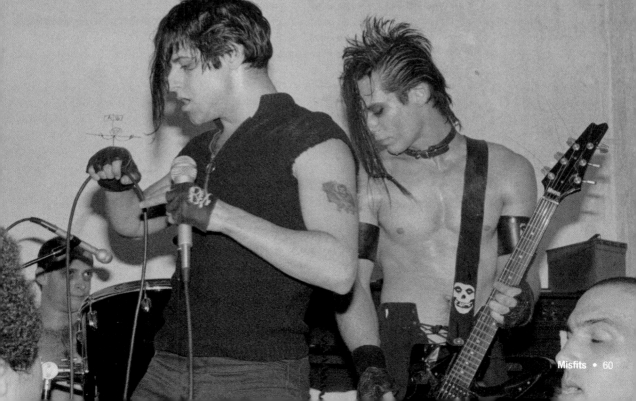

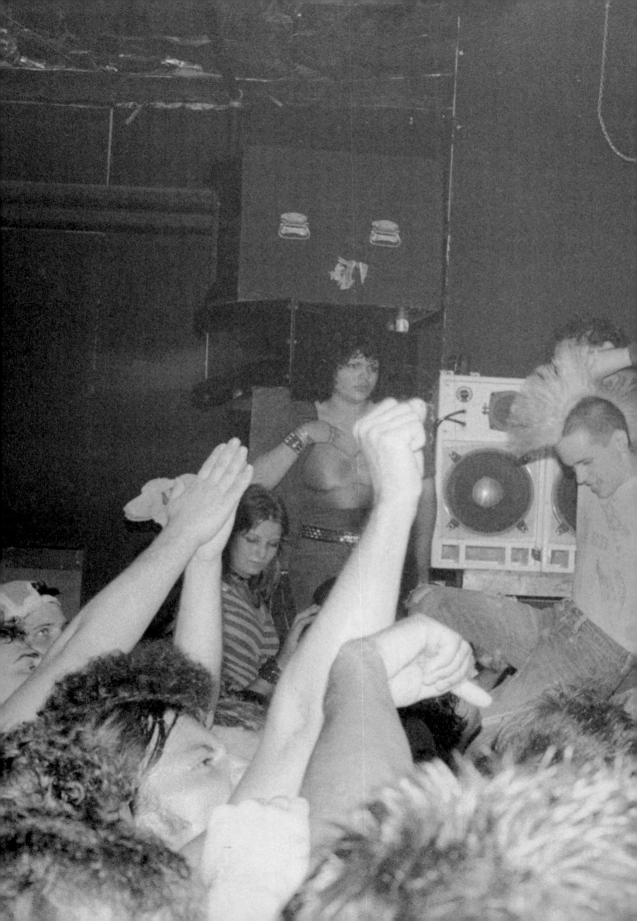

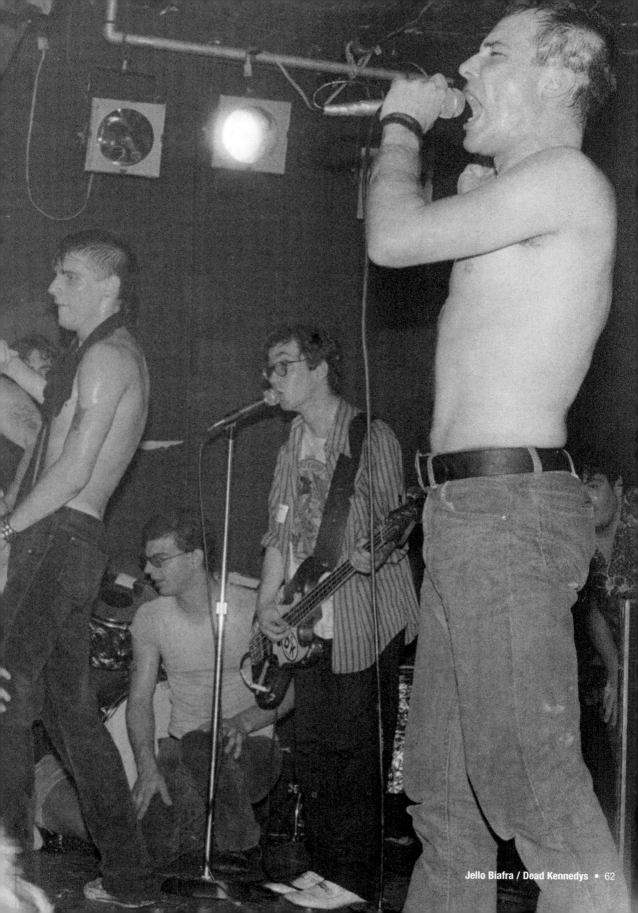

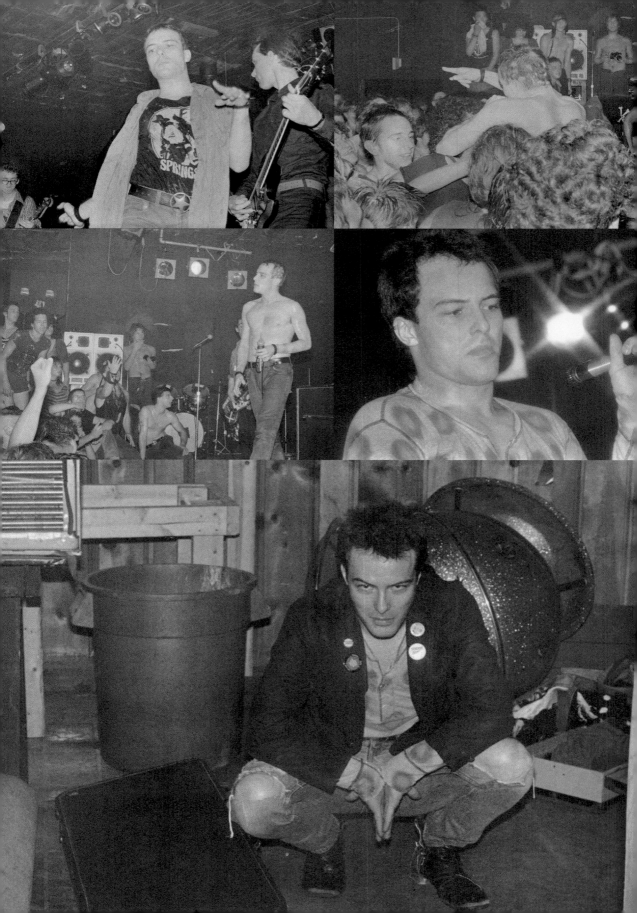

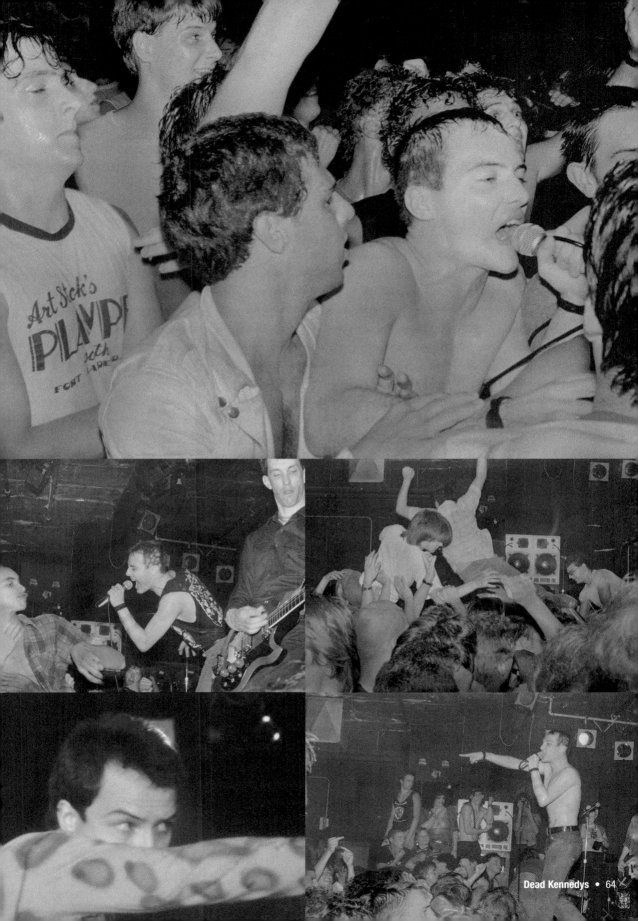

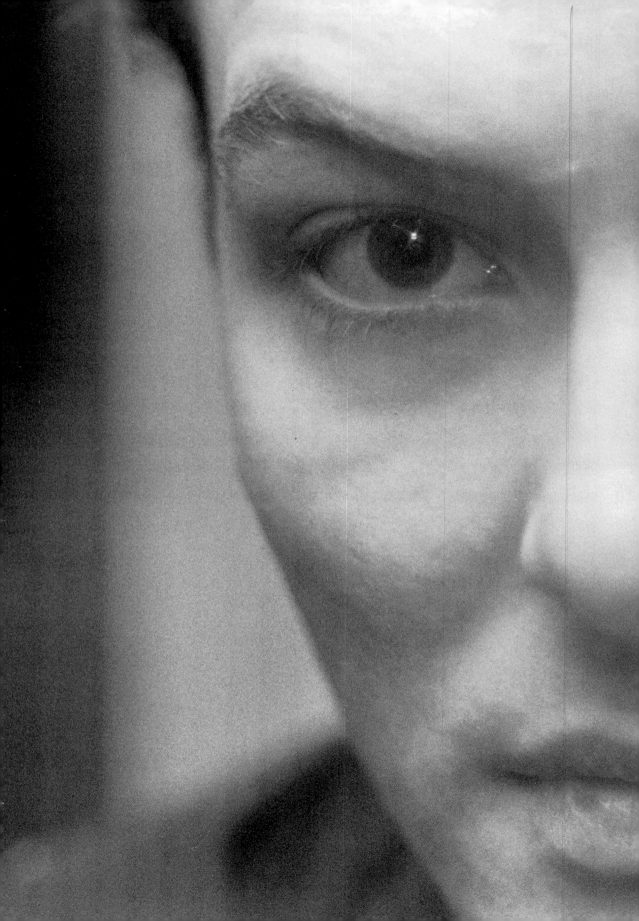

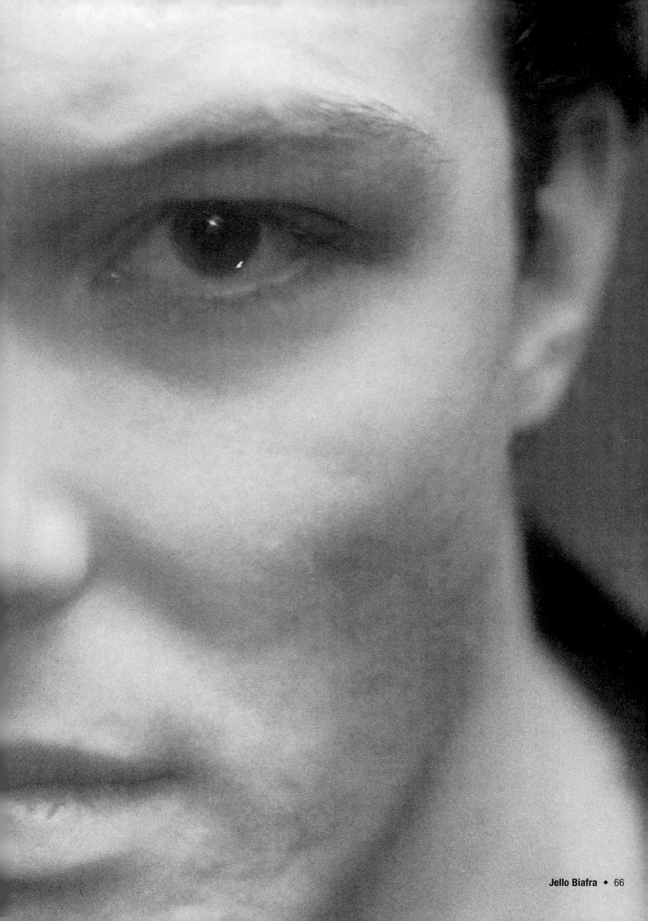

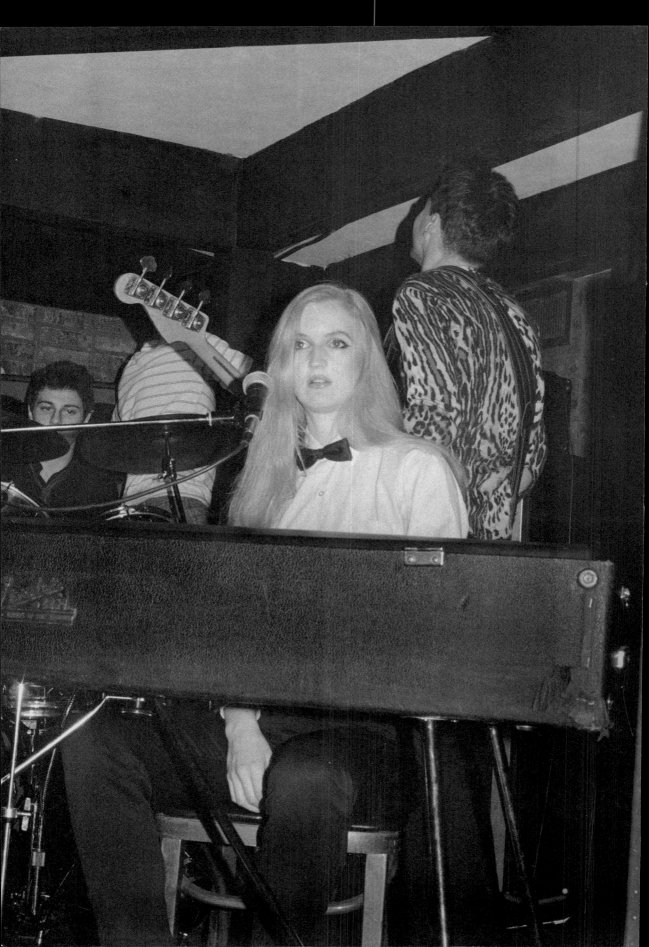

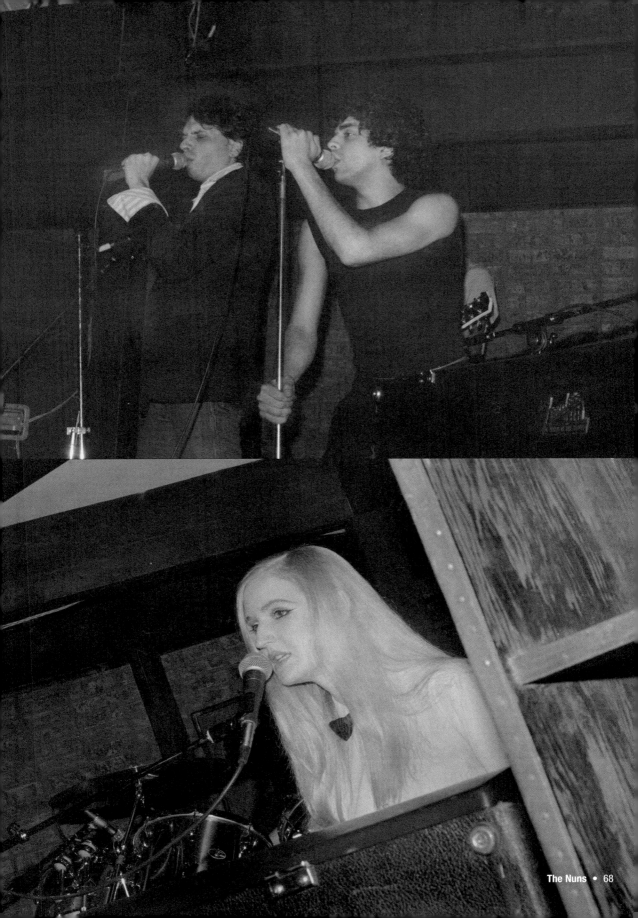

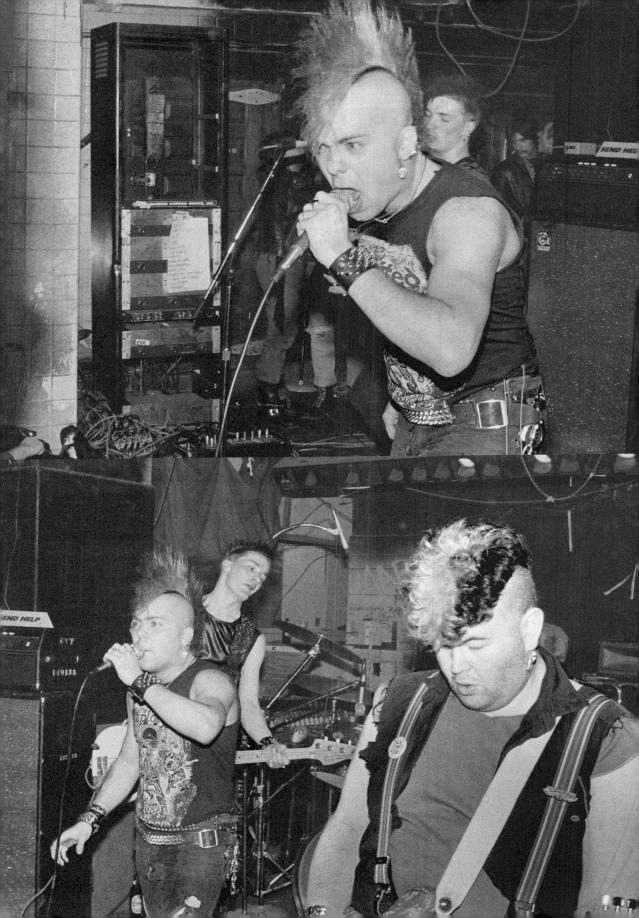

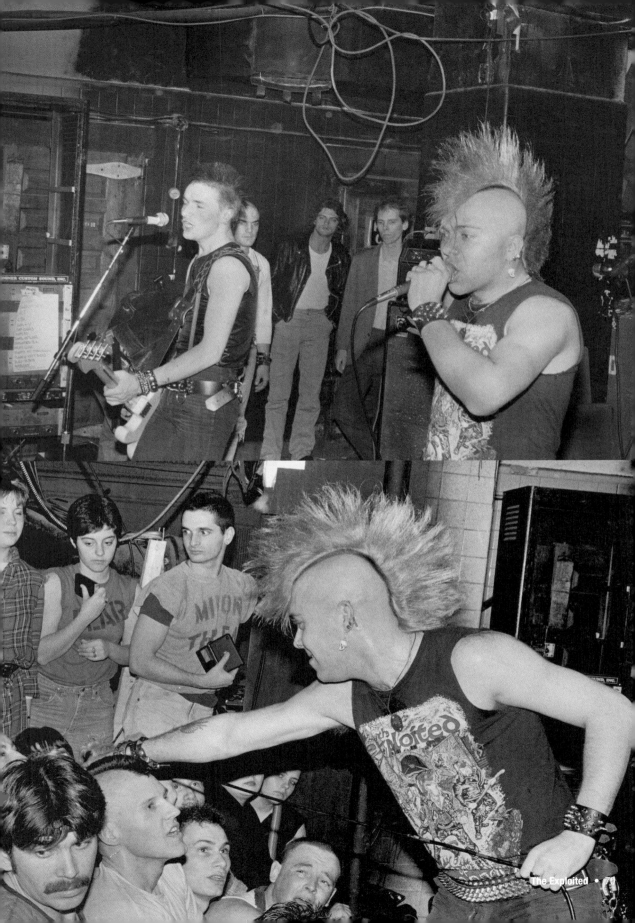

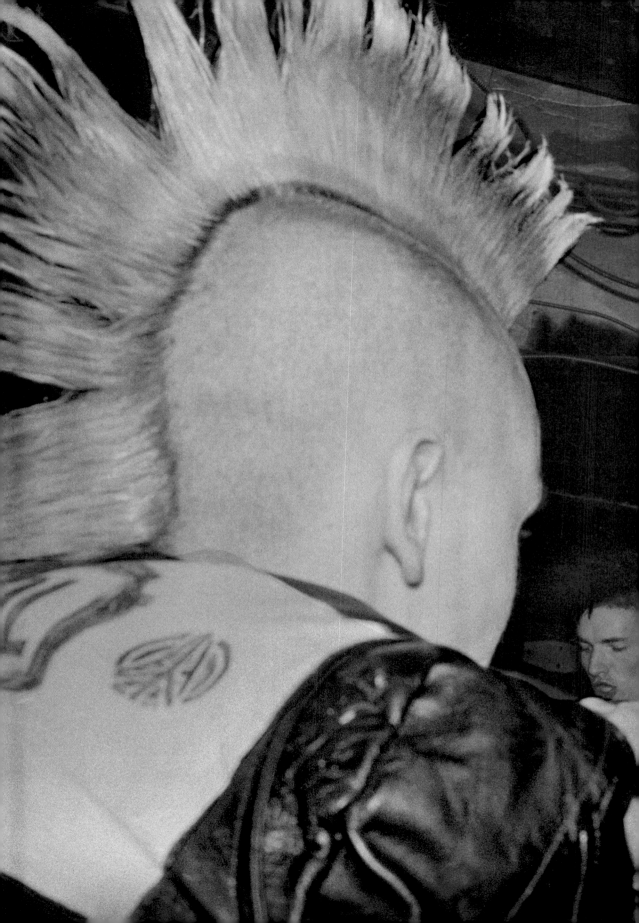

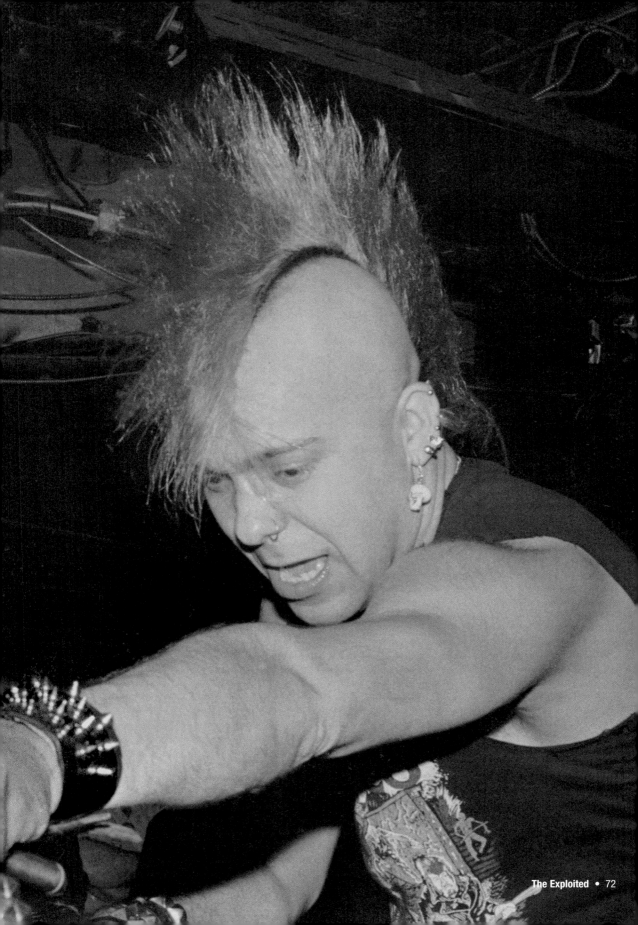

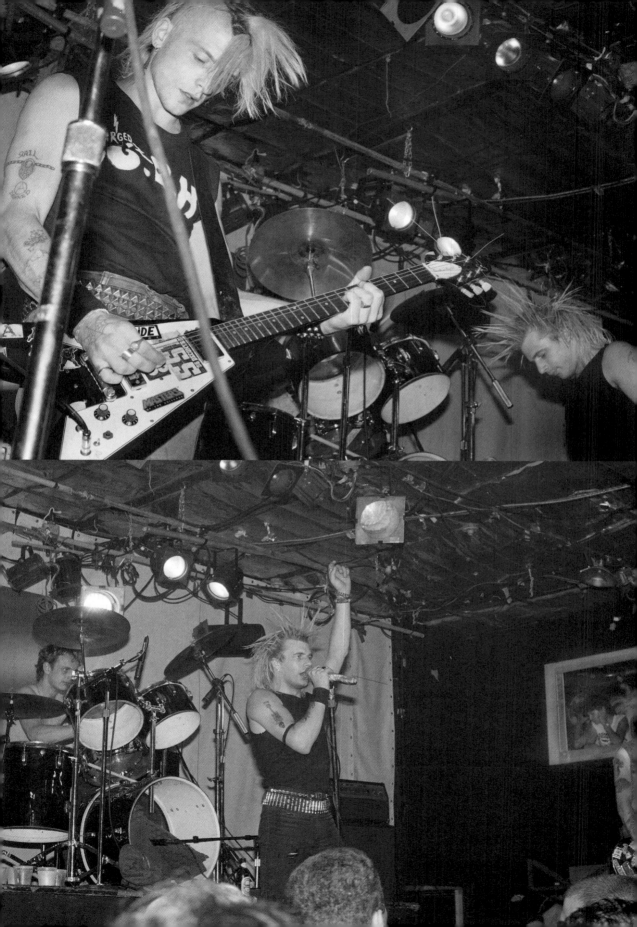

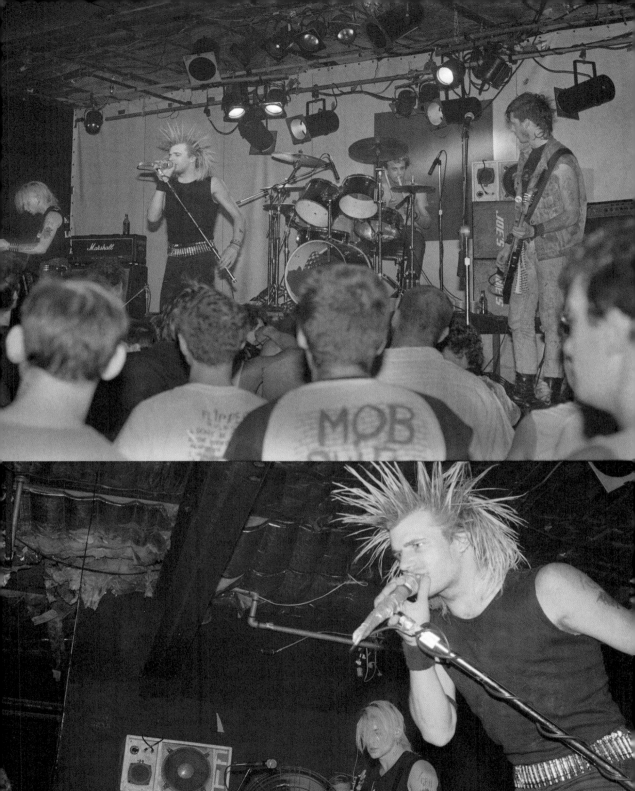

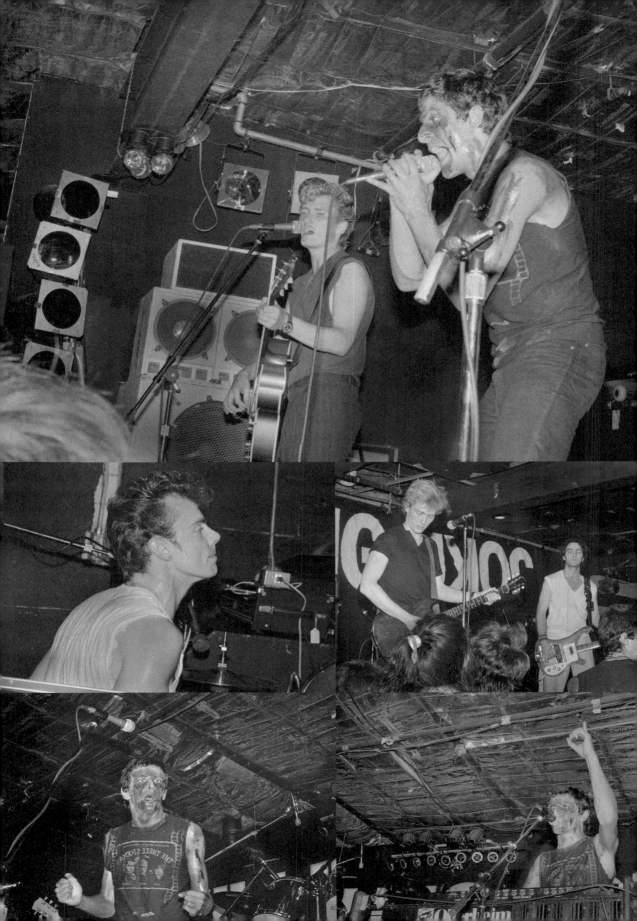

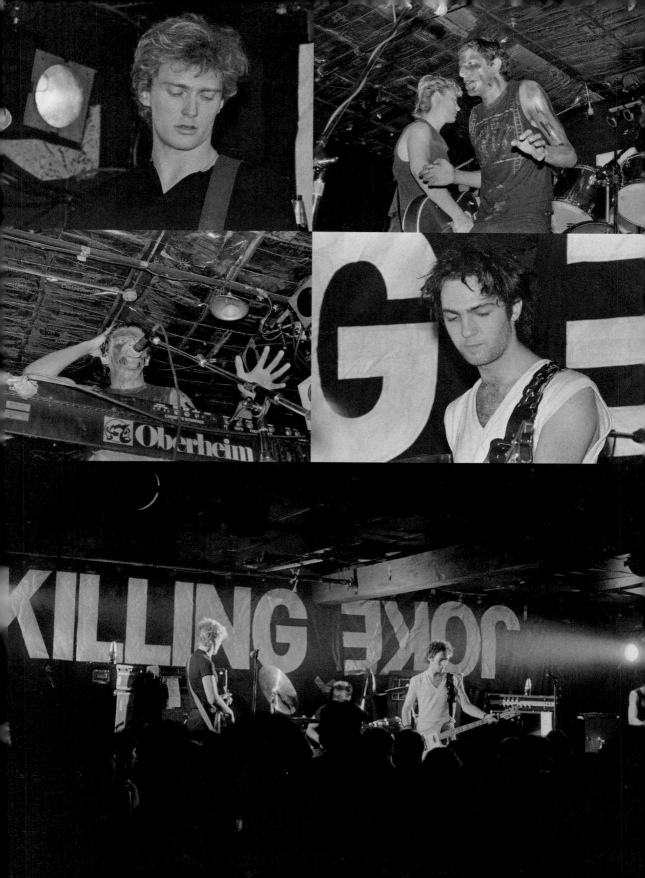

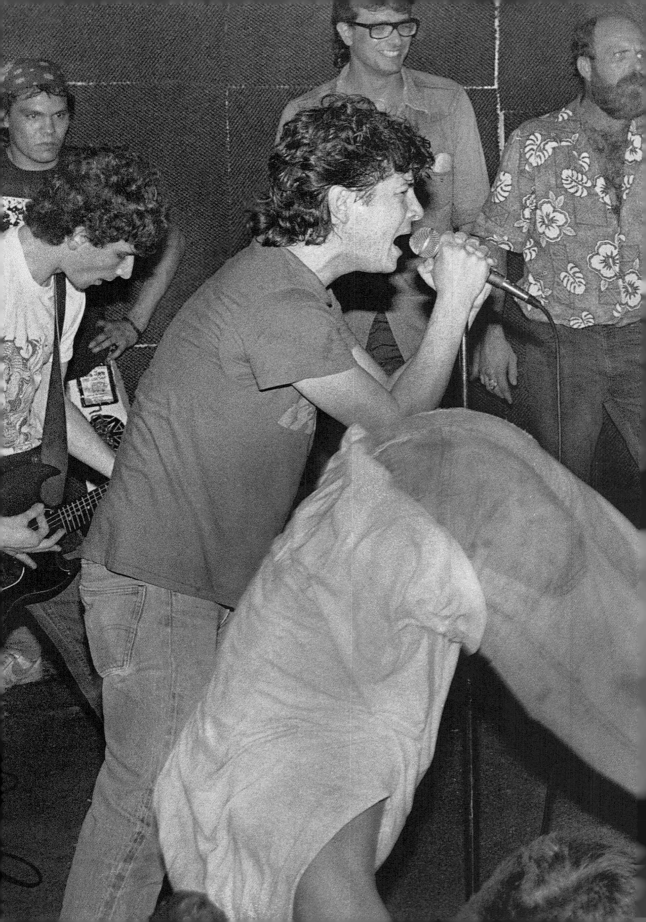

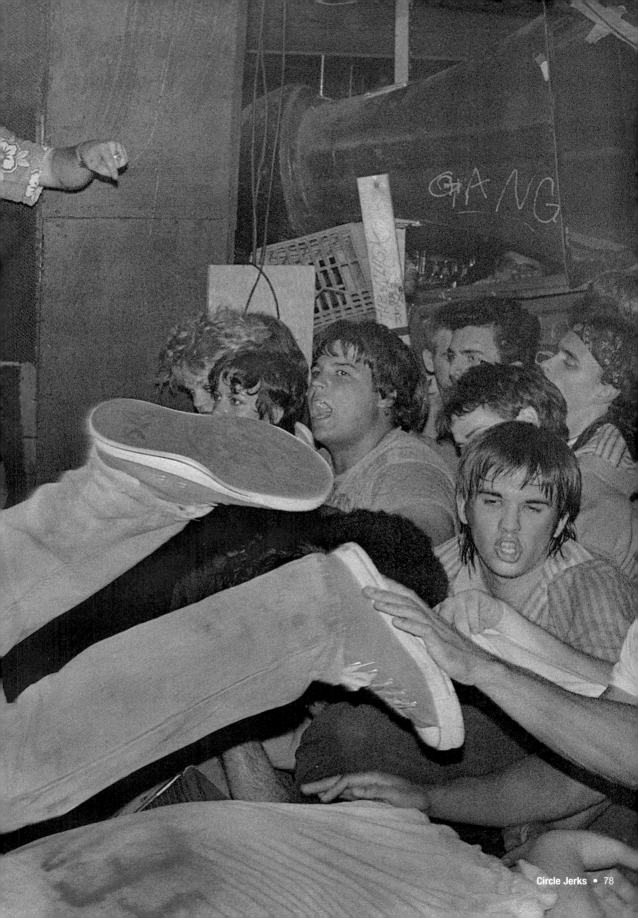

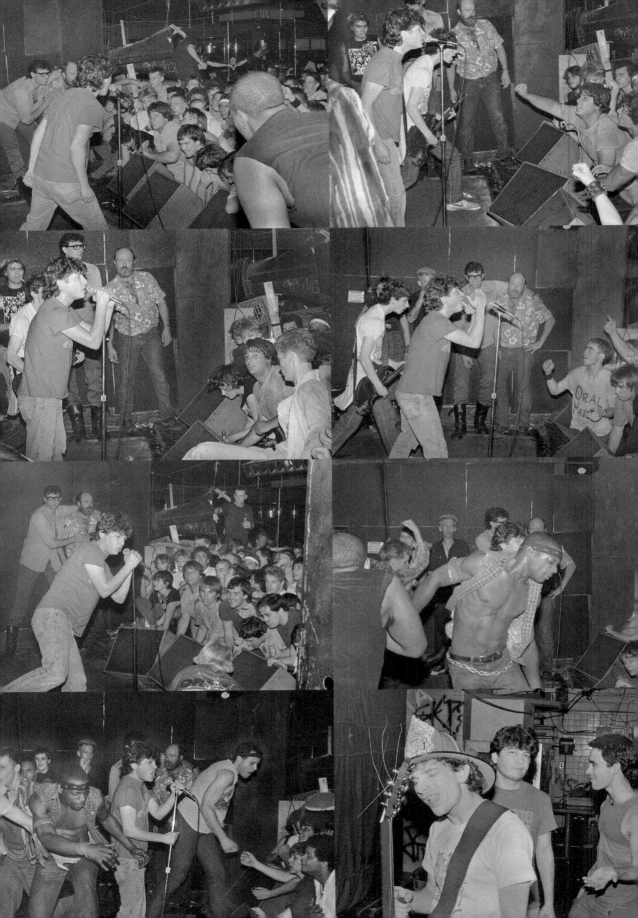

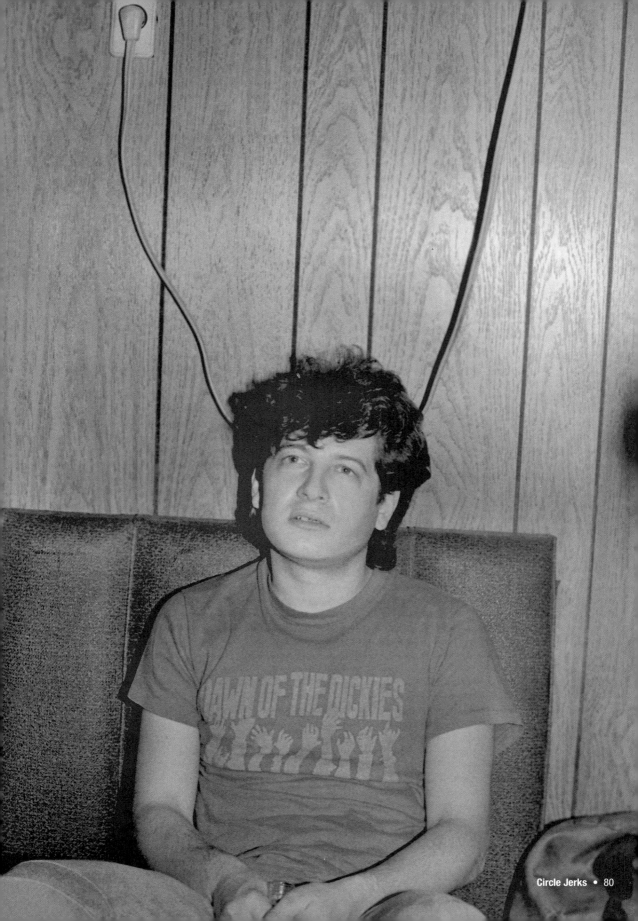

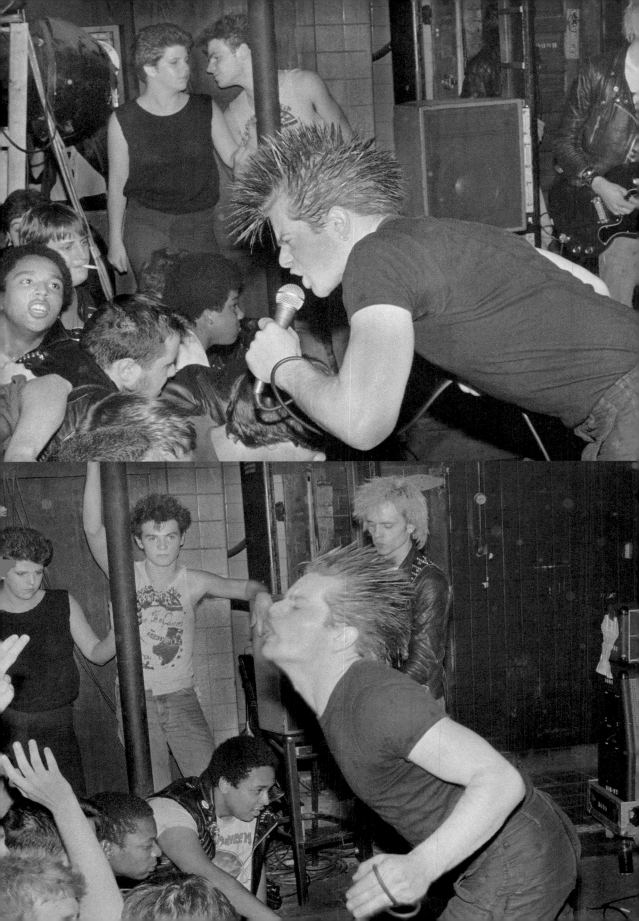

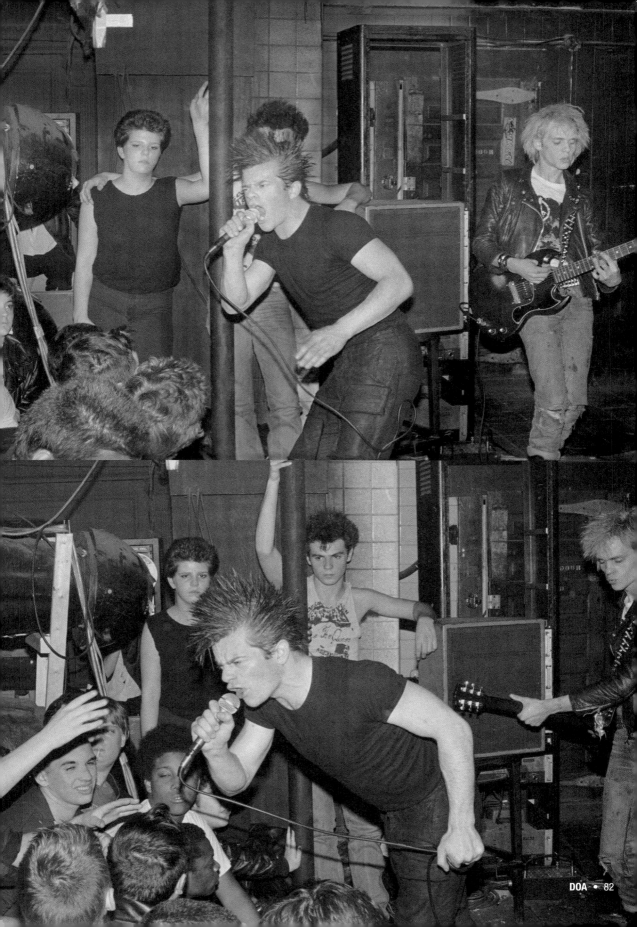

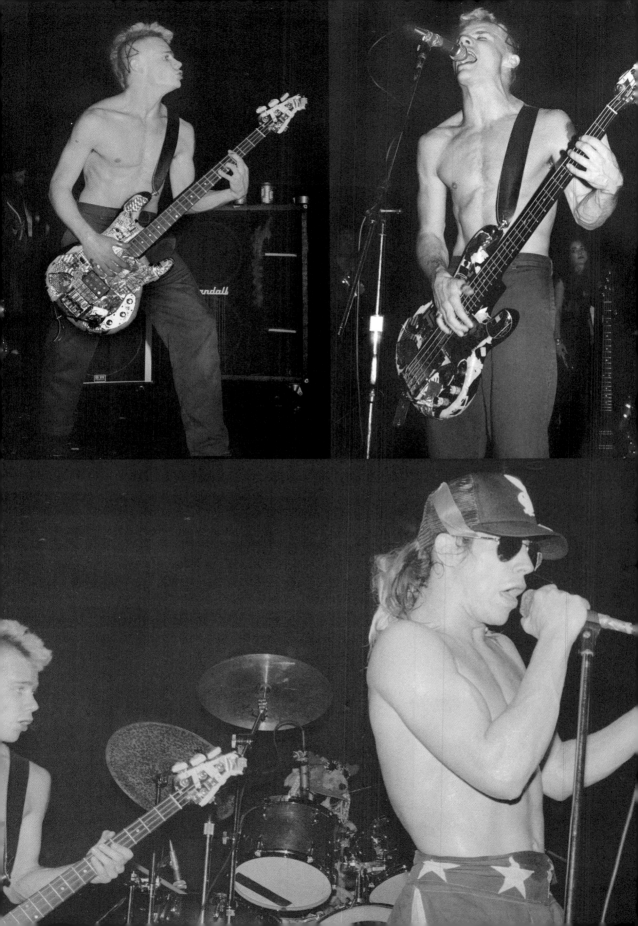

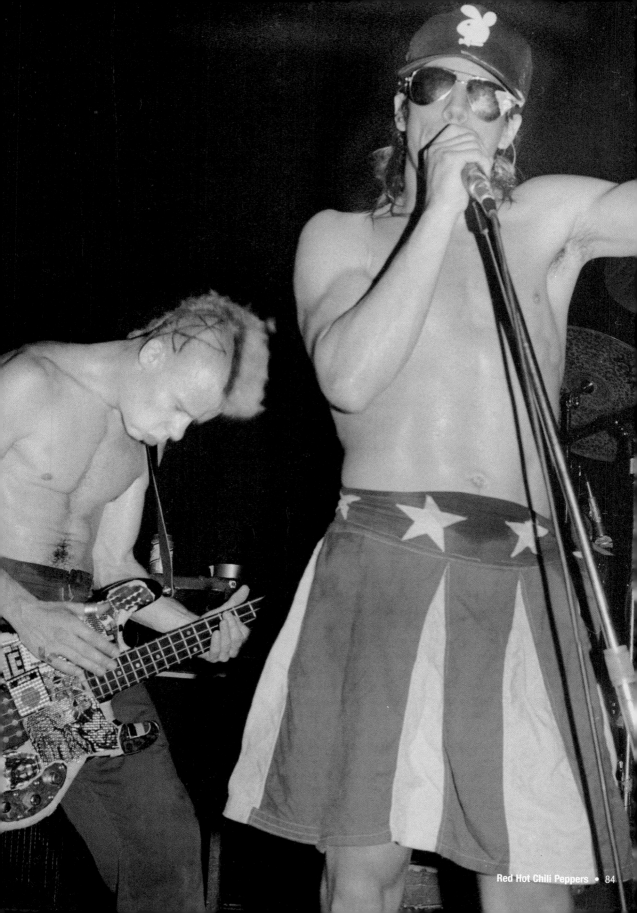

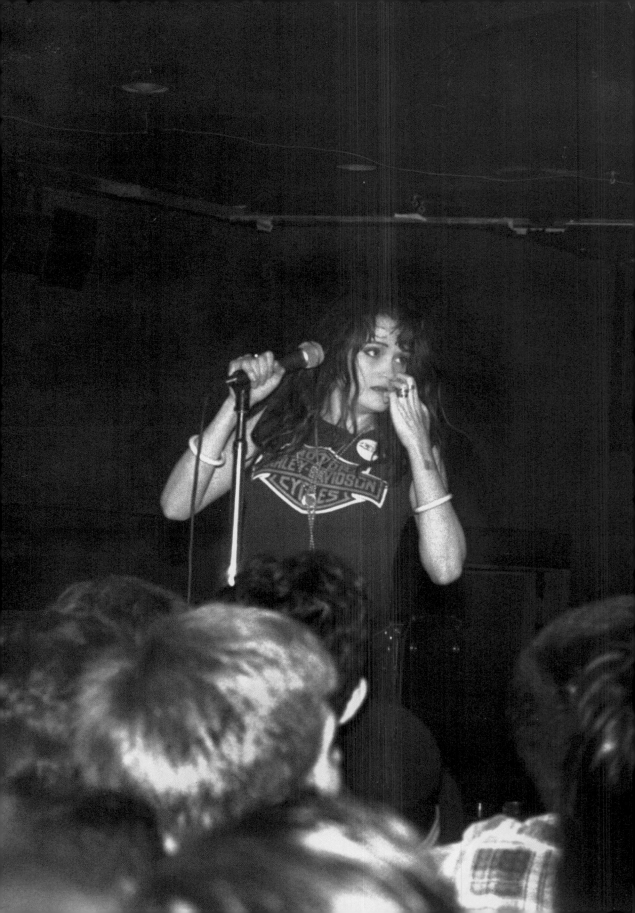

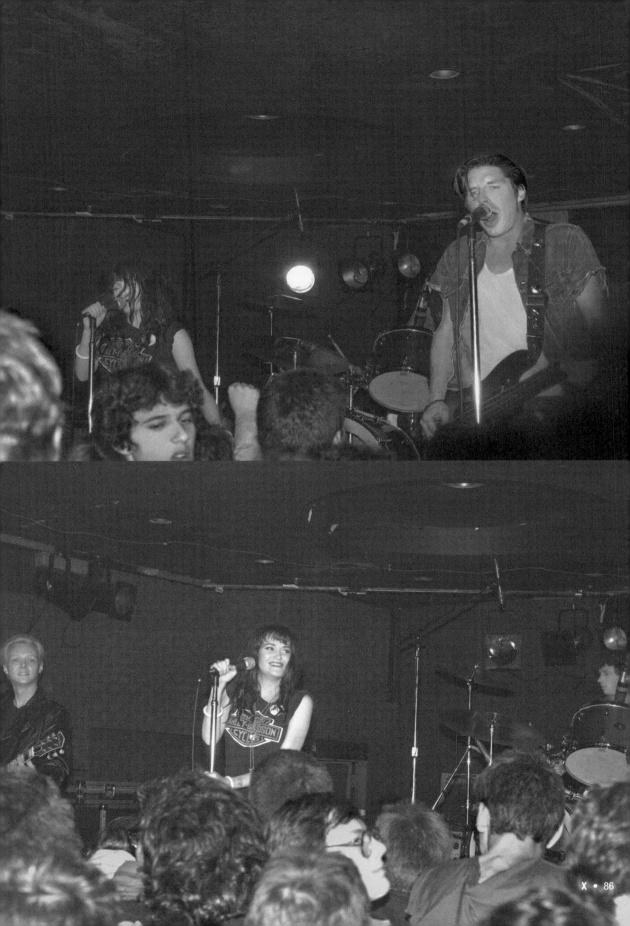

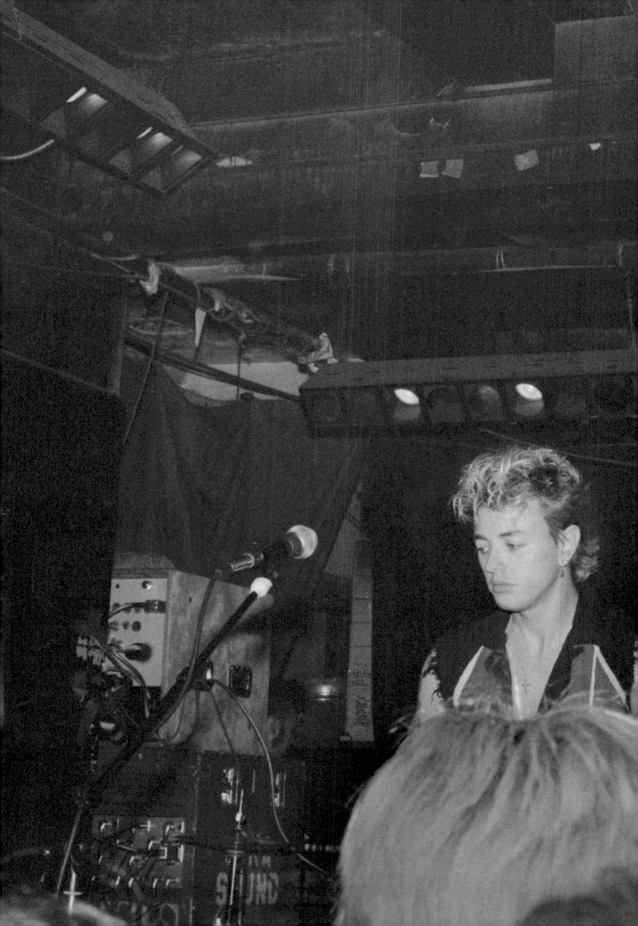

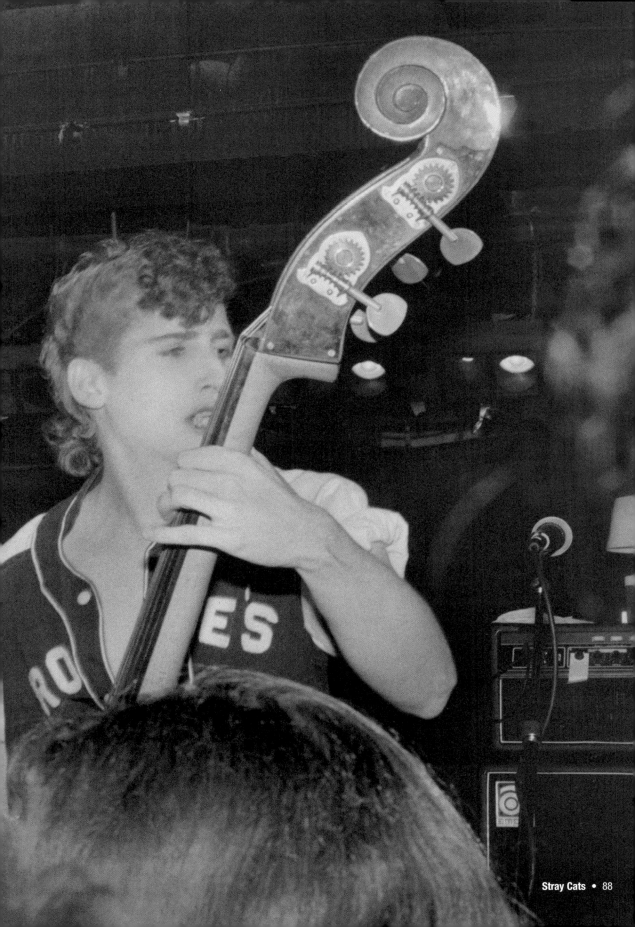

Stray Cats • 88

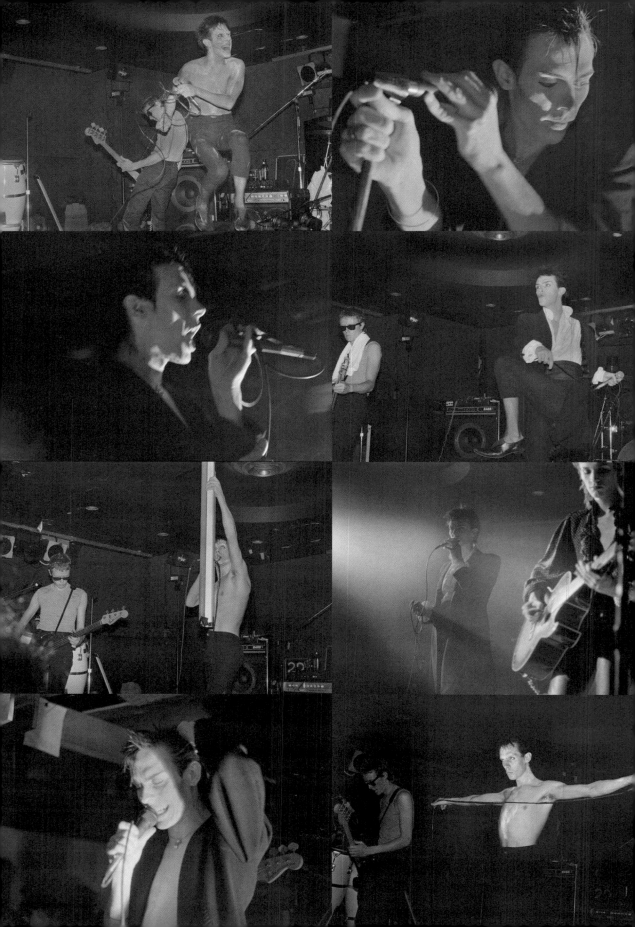

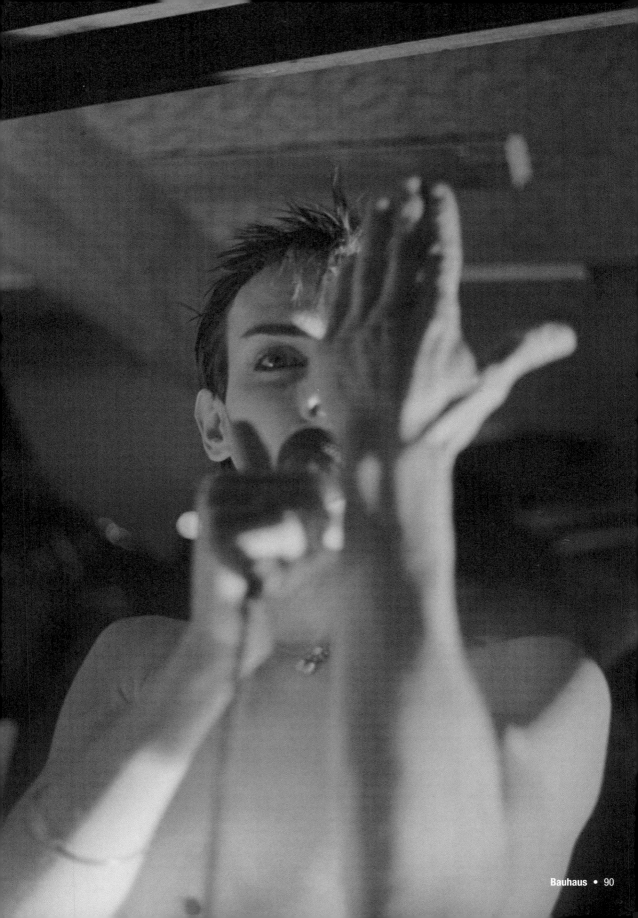

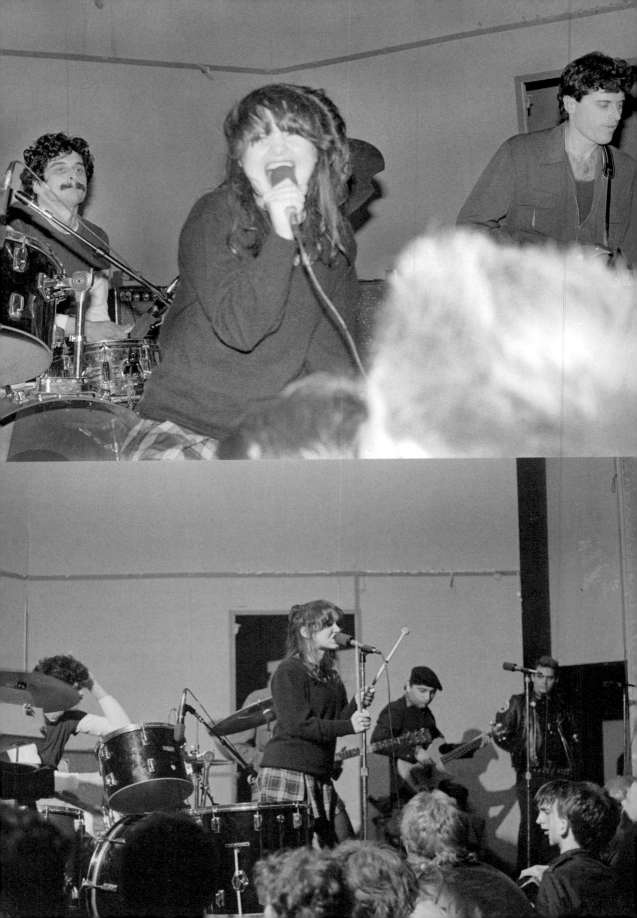

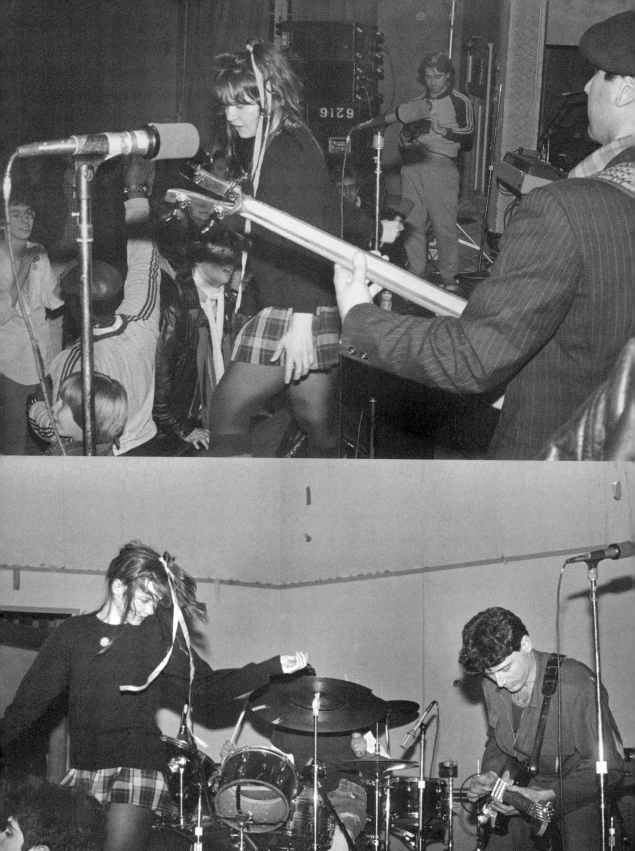

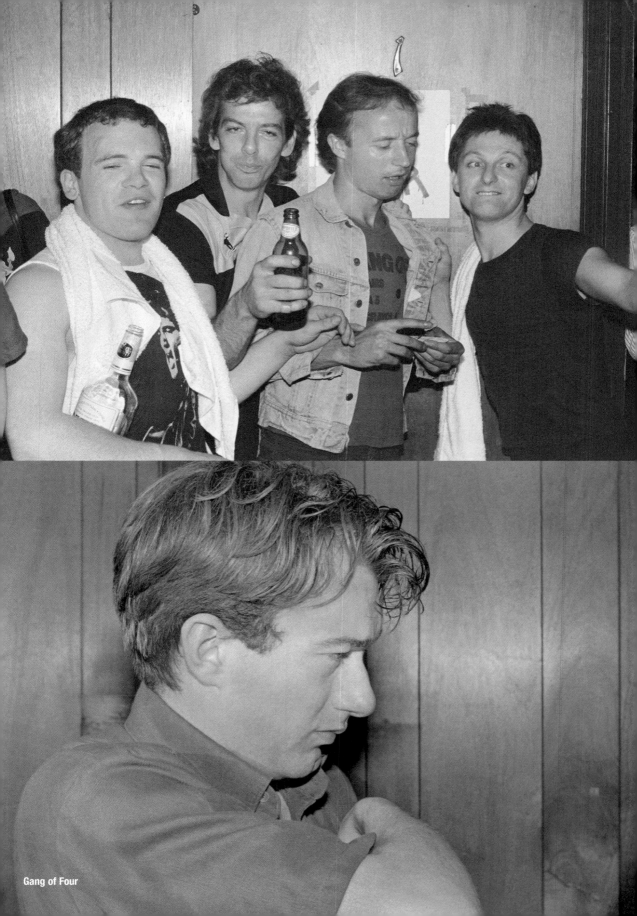

Gang of Four

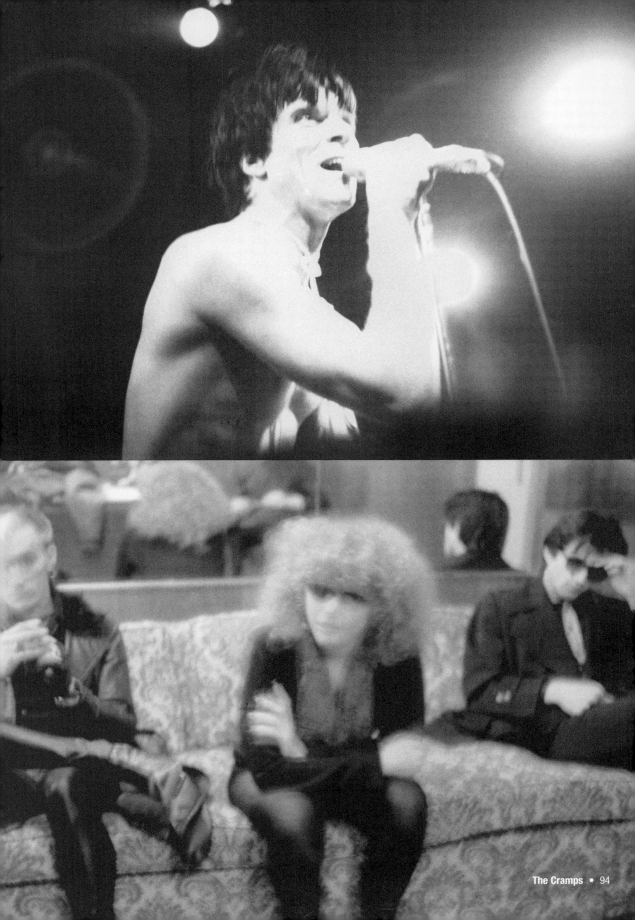

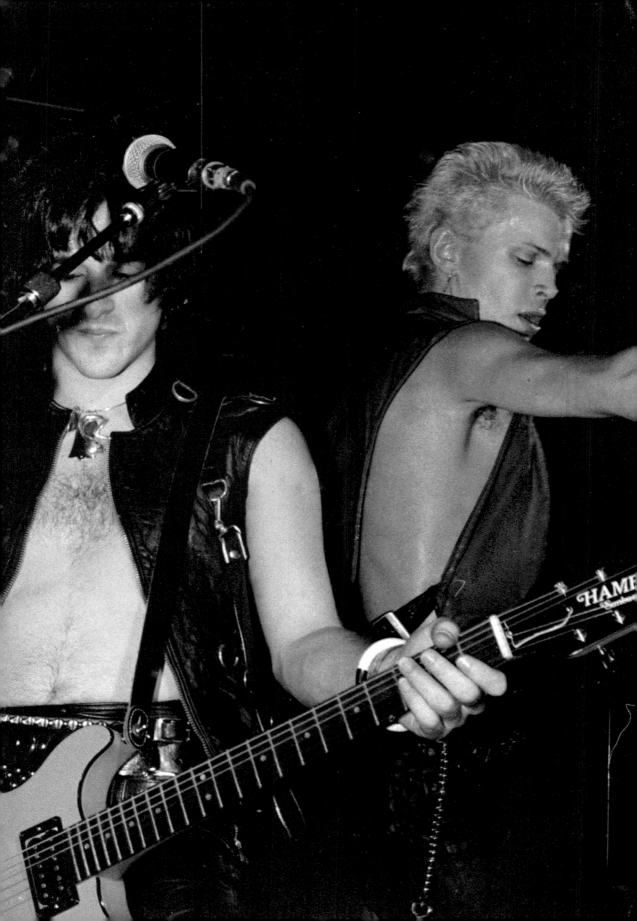

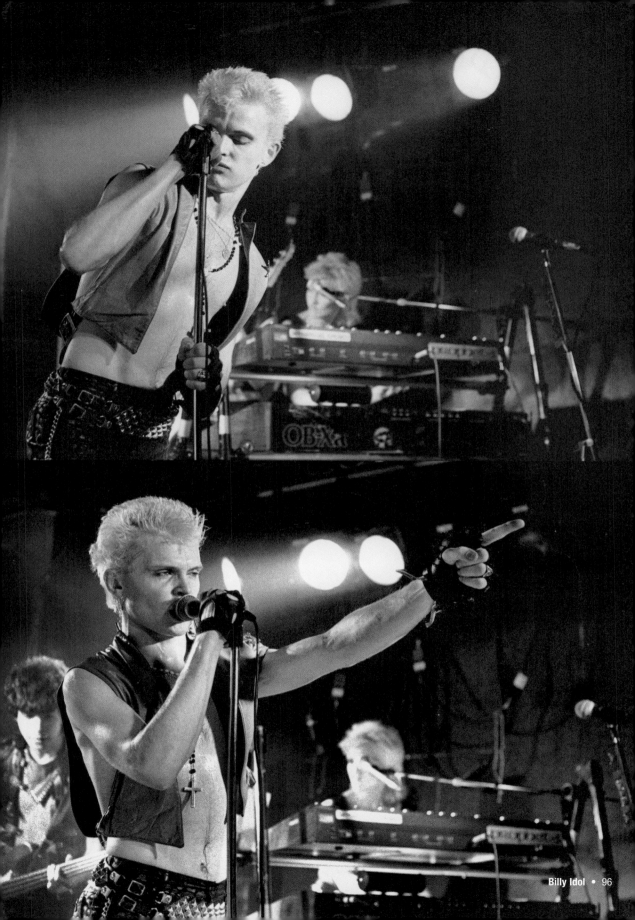

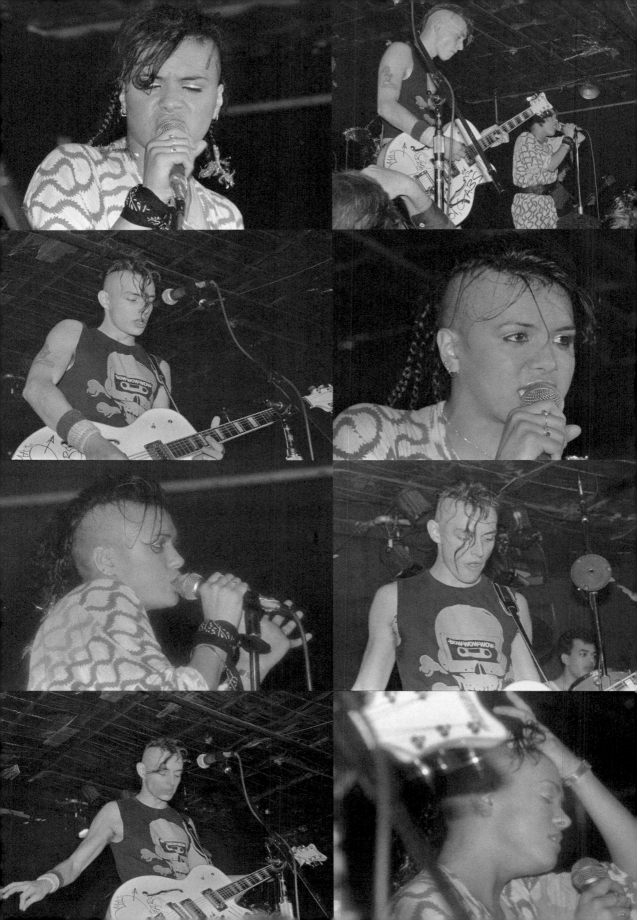

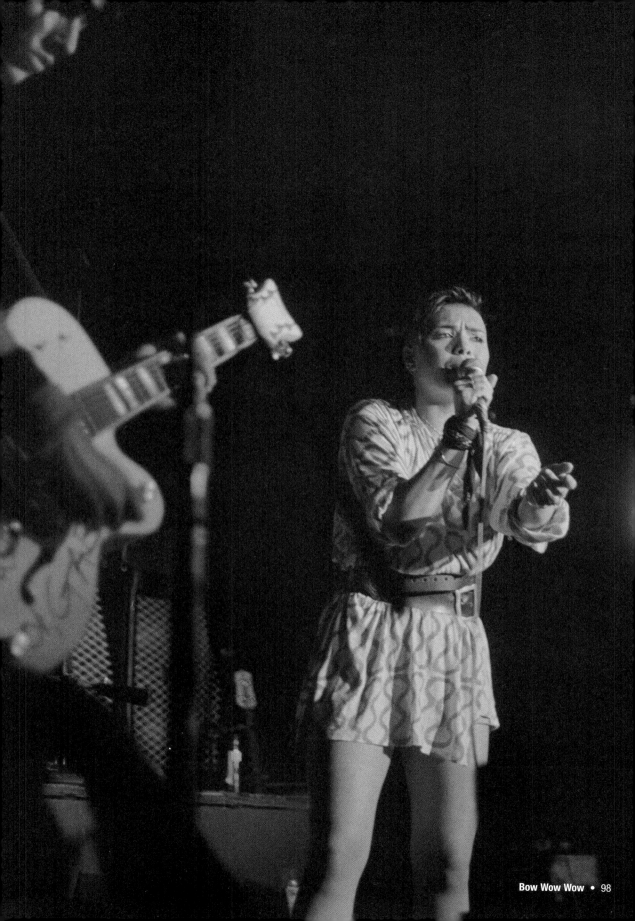

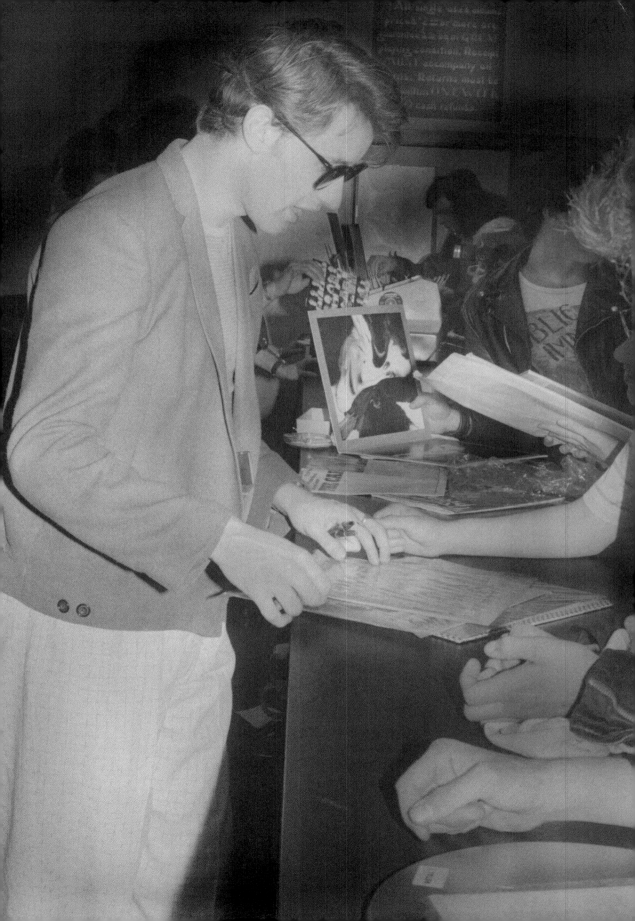

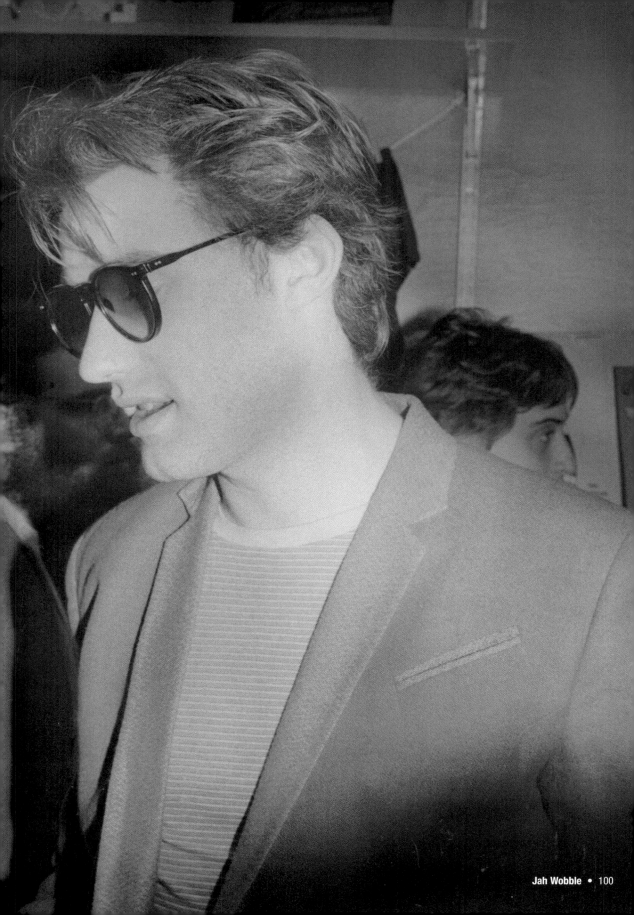

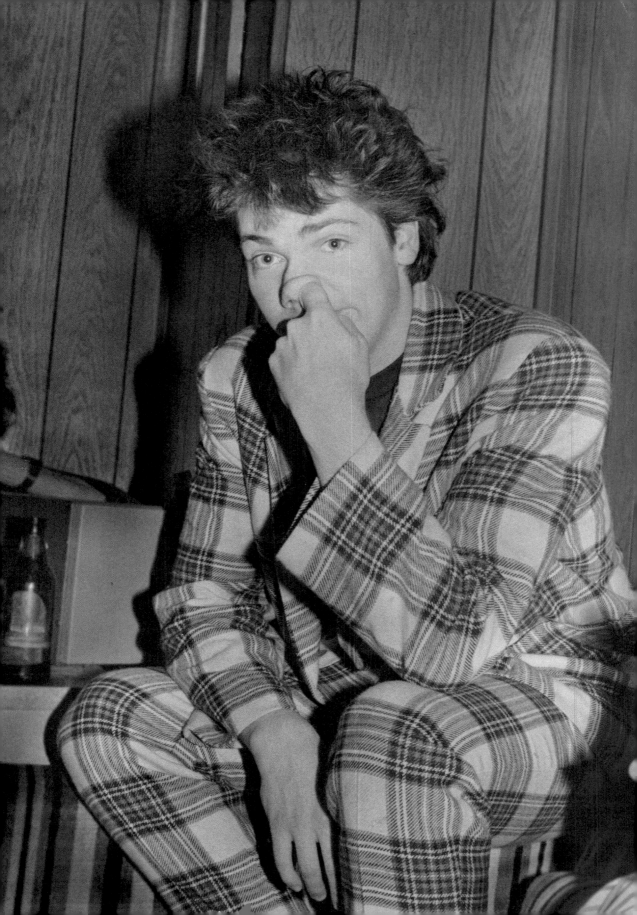

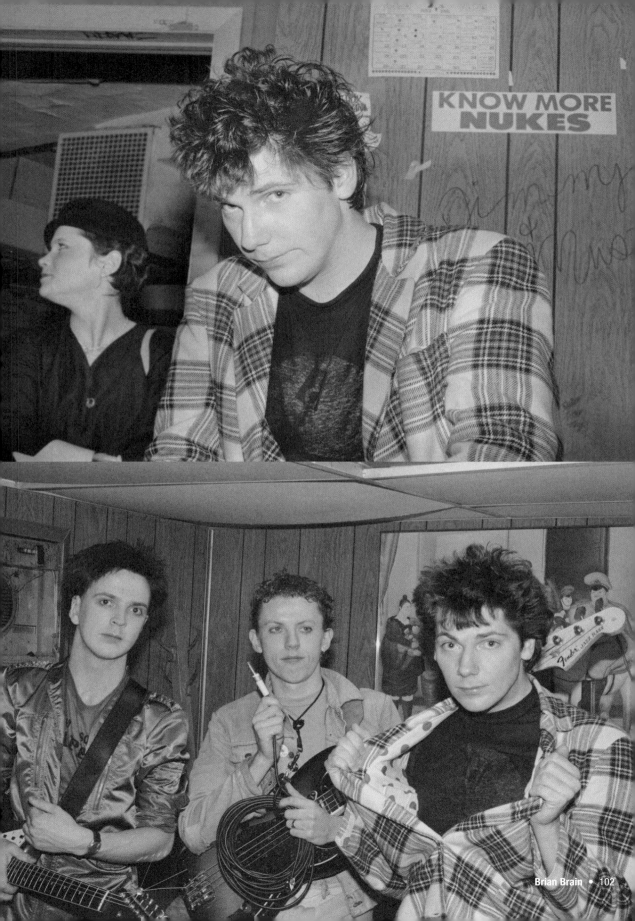

KNOW MORE
NUKES

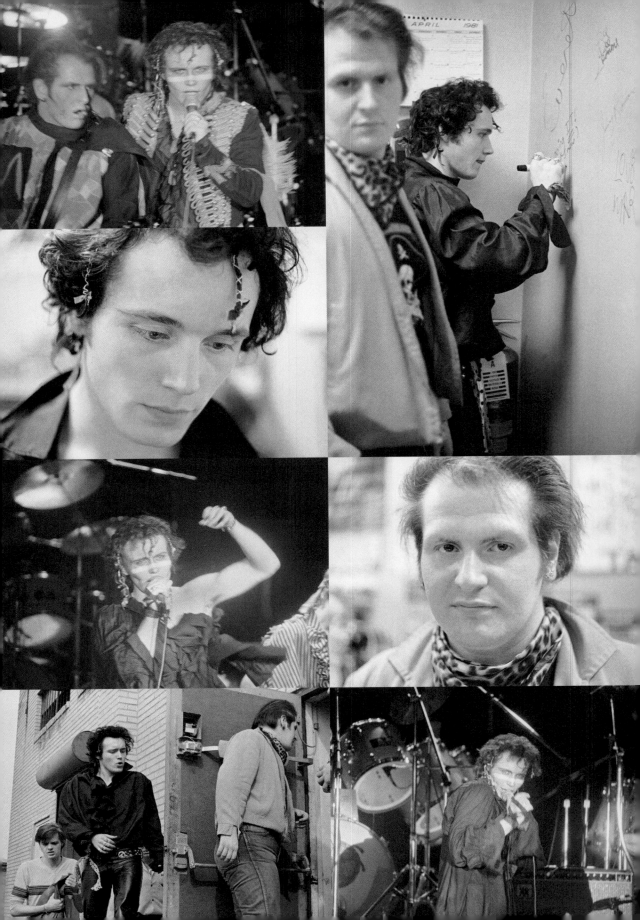

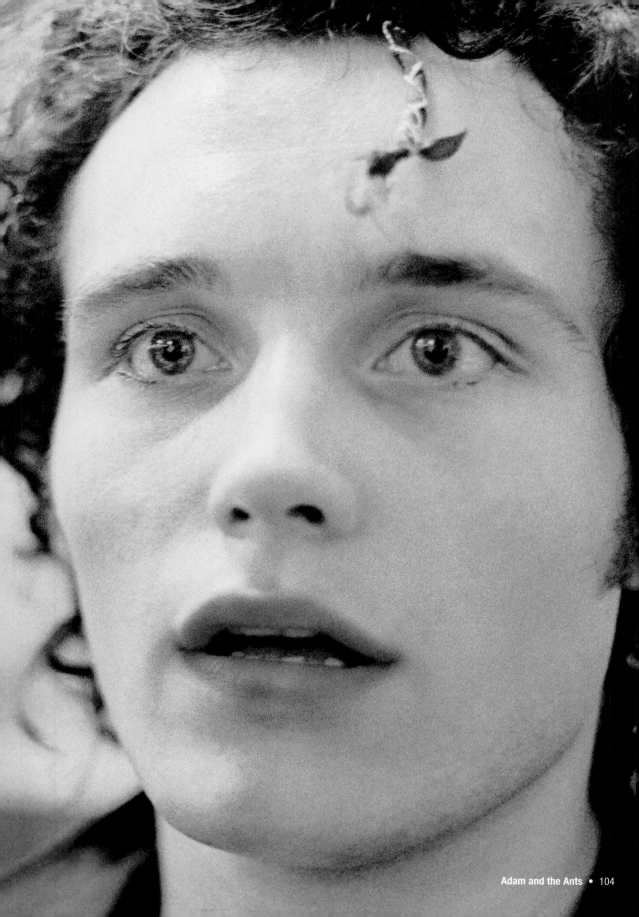

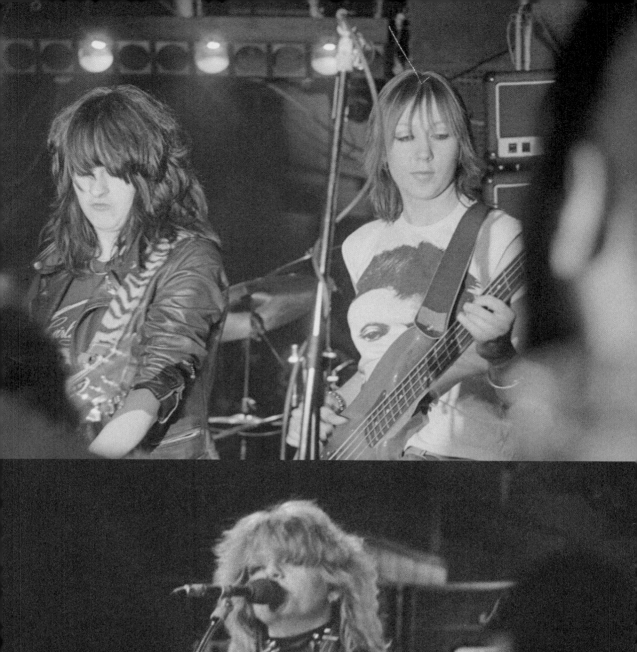
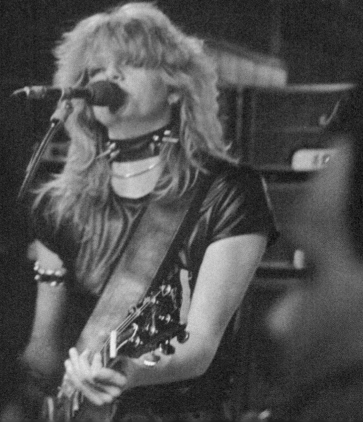

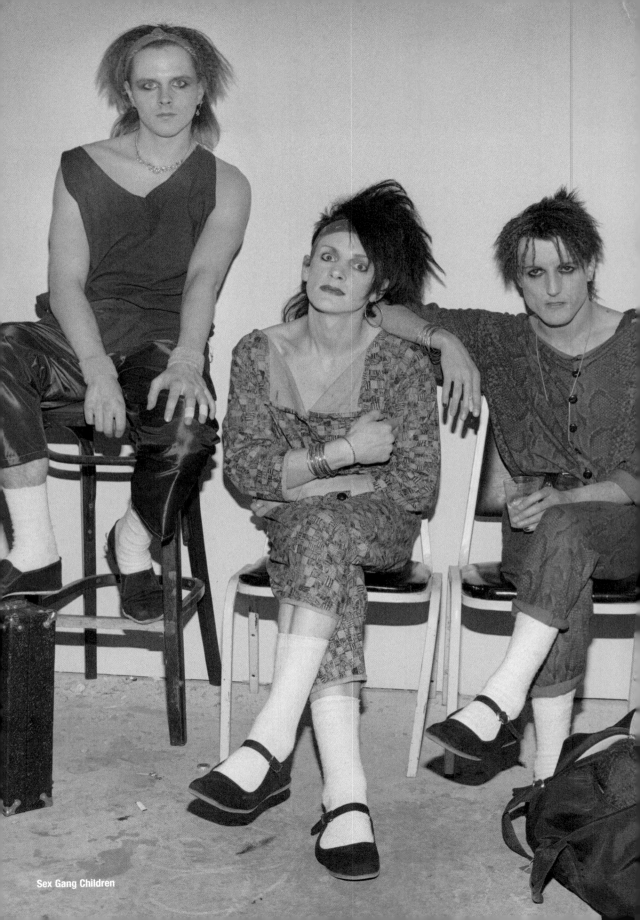

Sex Gang Children

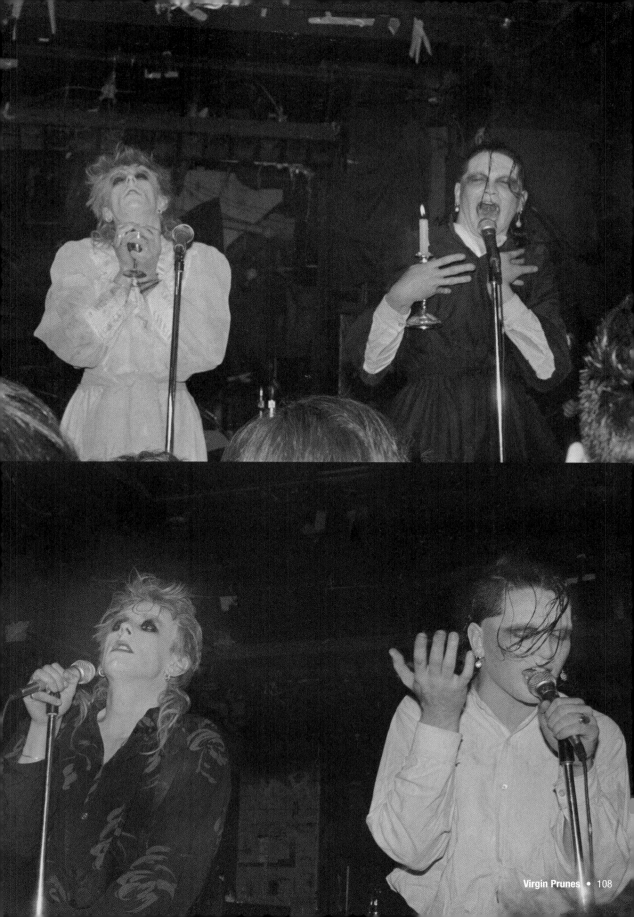

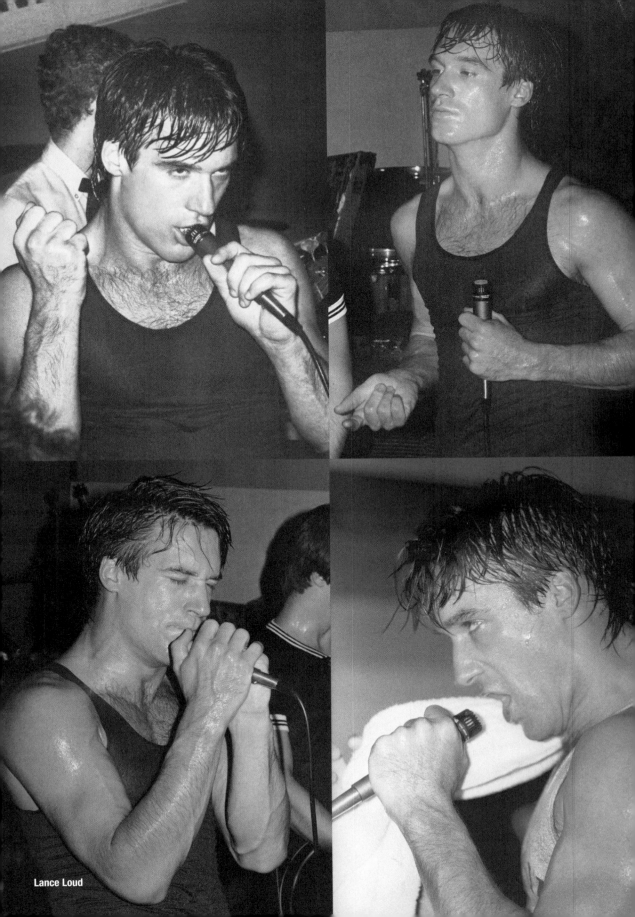

Lance Loud

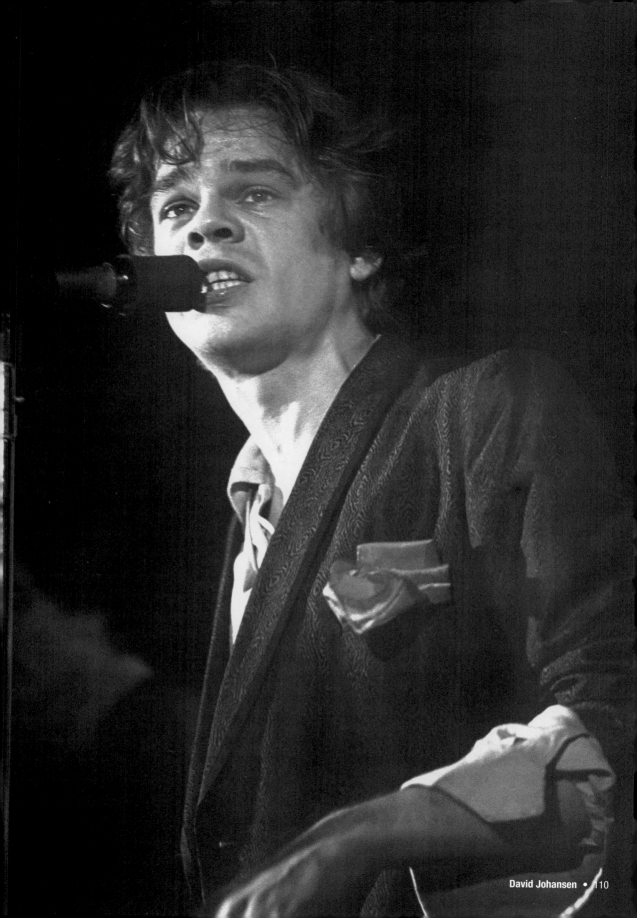

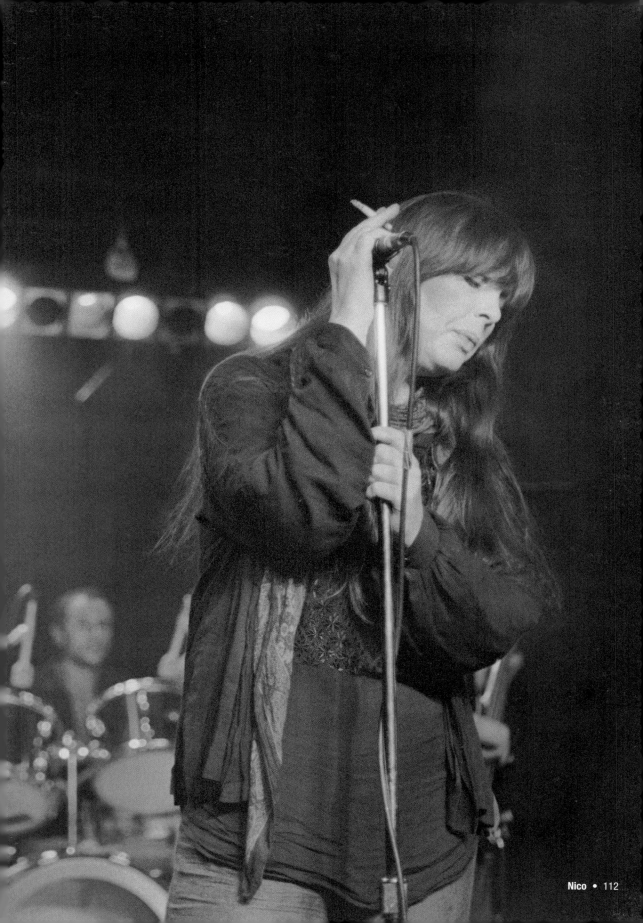

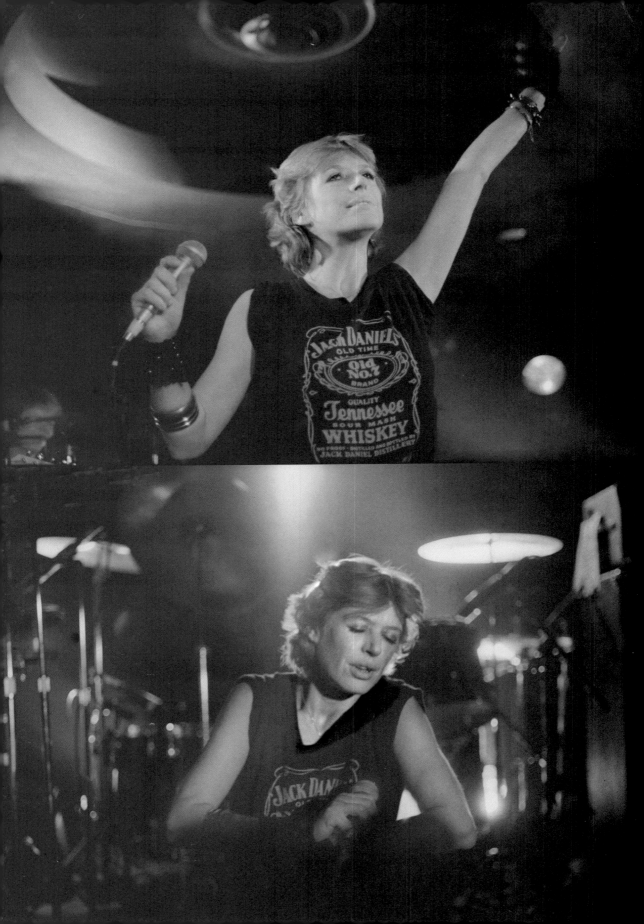

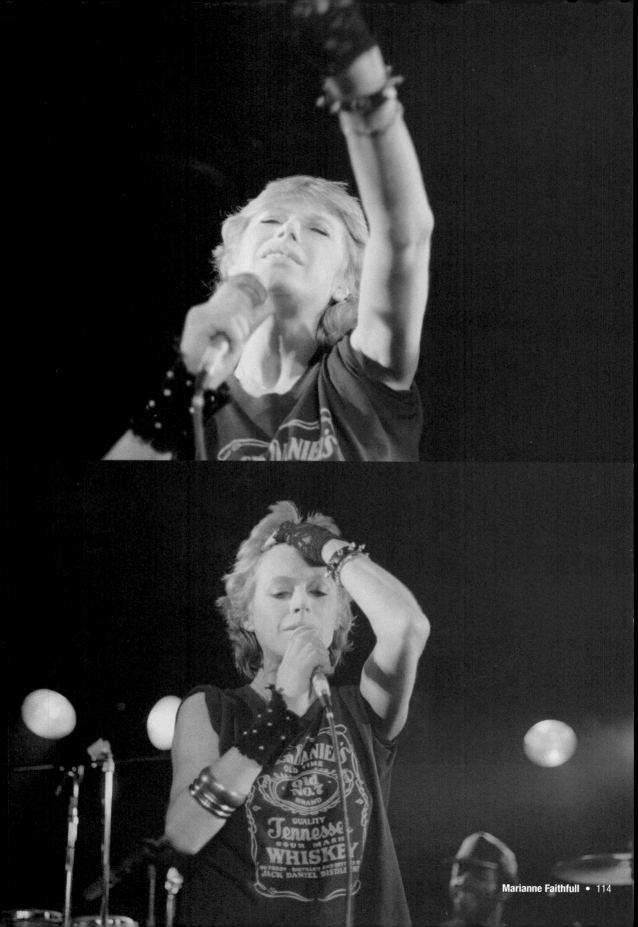

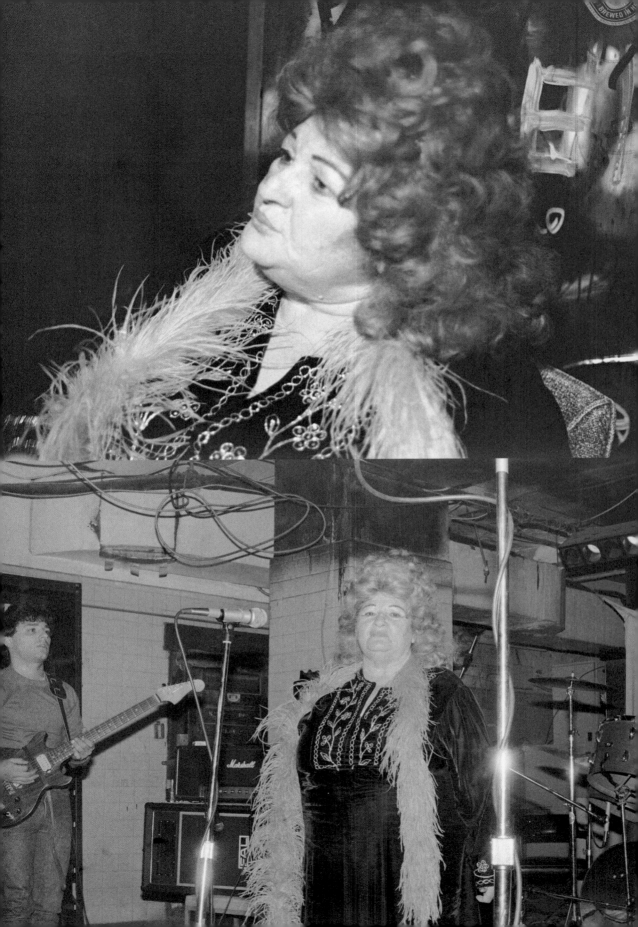

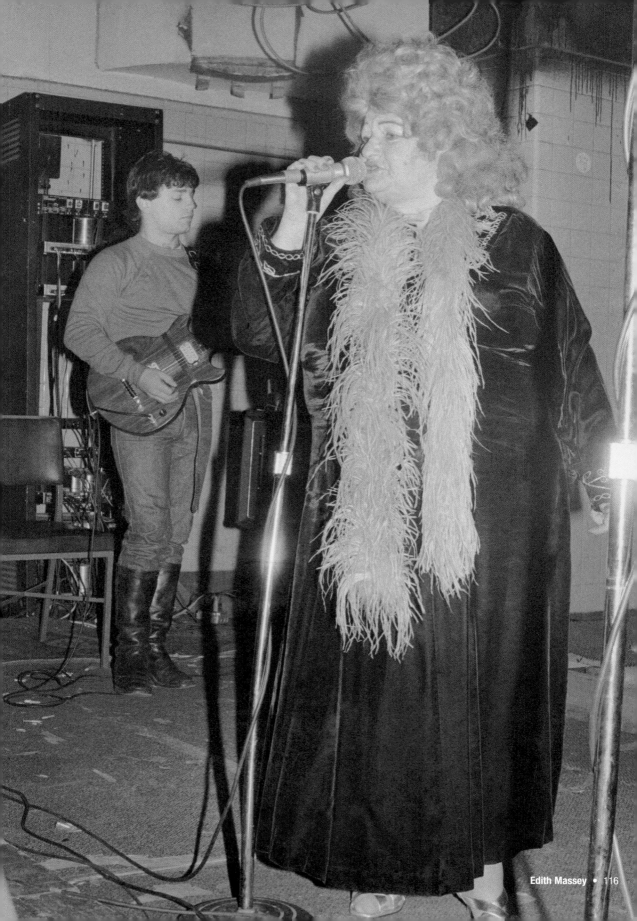

NOTES

Cover Image: Sid loved the camera and posed for me from the stage at Max's Kansas City in Manhattan. My "secret technique" was to use 400 ASA black and white film pushed to 1600 and developed in a fine grain developer. I never had to use a flash for stage shots.

Endpapers: Misfits - I learned to use a flash and started using 100 ASA film. I was the lead singer in a band and we opened for the Misfits once. Glenn Danzig (lead singer of the Misfits) called me a "spastic Jerry Lewis."

Pages 13-14: PIL - This is the only show where my camera nearly got smashed because of the crowd. I had to retreat to the back.

Pages 19-24: Patti Smith - I photographed Patti many times at many different shows. One time at CBGBs I passed Patti on my way to the bathroom and told her that people were getting kicked out of the club for no reason. She turned to me and said: "Am I my brother's keeper?" Pages 23/24: I call this my Patti Angel/Devil spread.

Pages 25-30: Ramones - I pinned the button of Elvira the Pinhead on Dee Dee this night and photographed him wearing it. I saw the Ramones so many times. Dee Dee was my favorite. They were really especially fun.

Page 34: Blondie - I was the only punk on my college campus and was a photographer on the year-book staff when Blondie played our campus. We hung out in a locker room together and it was the first time I ever used a flash. I was gabbing to Debbi in the girl's bathroom as she put on her makeup. There was a wall-length mirror with a single vertical crack in it. Of course she chose to use that exact spot for her makeup. We laughed a lot and she kept pinching my cheeks saying "As cute as you are!"

Pages 35-42: The Clash - These pics are from two different shows. Both in Philadelphia, one at the Walnut Street Theater; the other at the Tower Theater.

Pages 49-50: Siouxsie and the Banshees - This show was in Fishtown in Philadelphia. We hung out upstairs in the dressing room while my friend Jere helped Siouxsie with her makeup. The film got stuck in my camera and I accidentally started double-exposing frames. A friend of mine had fake hand grenades that nearly got him in big trouble.

Pages 51-54: The Slits - The Slits played this show in New Jersey-just across the bridge from Philly. I photographed them for an interview before the show and Ari Up yelled at my friend for wearing a t-shirt that had victims of Jack the Ripper on it. Ari was known to be "difficult."

Page 55: Lydia Lunch - When I asked Ms. Lunch if I could photograph her, she answered, "You want a shot. I'll give ya a shot and it'll be a rare one!"

Pages 57-58: Stiv Bators and the Dead Boys were super-popular in New York. Stiv was pretty aggressive on stage. I got his bloody tampon shirt after this show. One night at Max's Cheetah Chrome threw me up against the wall for some reason. One of the band members pulled him off of me.

Pages 65-66: Jello Biafra - I shot the Dead Kennedys many times at many shows. This one was in Trenton, New Jersey. I was backstage with camera in hand where Jello kept telling me, "Just get my eyes, just get my eyes!!"

Pages 71-72: The Exploited - The lead singer of the Exploited handed the mike to my friend Keith and the image looked like a mirror to me. I was always looking through my viewfinder and I snapped fast. I was usually sweating because it was so hot and the sweat would drip into my flash sync plug so whenever my finger brushed by I'd get a big shock. It wasn't pleasant.

Pages 77-80: Circle Jerks - These guys were fun for all the stage diving madness they encouraged. I usually had to climb onstage to take photos and I would squeeze myself into a corner out of harm's way.

Pages 83-84: Red Hot Chili Peppers - I shot these in San Francisco for a newspaper article. They played on or near Broadway.

Pages 89-90: Bauhaus - You could always count on Peter Murphy for good pictures. He was theatrical and visual so it was fun trying to capture it.

Pages 91-92: Raincoats - Palmolive left the Slits and played solo shows. This was an all ages show in a big hall type place.

Page 94: The Cramps - This show was in London where I was studying. With my American accent I figured everyone at the club would think I was with the band so I just walked backstage. Being very drunk, this photo is the blurriest one that I ever took.

Pages 95-96: Billy Idol - Shot at the East Side Club in Philadelphia. Billy Idol was still mostly unknown and had a lot of energy.

Pages 97-98: Bow Wow Wow - Anabella was sixteen if I remember right, and had to get her mom's permission for this tour.

Pages 99-100: Jah Wobble - Wobble came to the Plastic Fantastic record store when he was on tour with PIL.

Pages 103-104: Adam Ant - Cameras were strictly prohibited at Adam Ant shows so I had to take my gear apart and smuggle it in using various friends. We would meet inside where I'd gather my gear back together. These photos are from a record store promo visit in Philly and a show on the University of Pennsylvania campus.

Page 107: Sex Gang Children - Not long after the band started playing, the Philly club was raided. As the police were filing in we ran downstairs with the band and hid there.

Page 109: Lance Loud - The Mumps played with Lydia Lunch at Artemis, a tiny and hot upstairs club in Philly. I supplied the Mumps newsletter with photos and really liked the Crocodile Tears single.

Page 112: Nico - I remember Nico being really grouchy backstage before the show. The rumor was that she wouldn't go on until she had her shot of dope.

Pages 115-116: Grandma Edie - Edie was sitting in a chair and crying backstage before her show. I knelt beside her and asked what was wrong. She told me that everyone in the audience was gay. I was kinda shocked and asked, "But Edie, what's wrong with that? Gay people love you, too."

Pages 119-120: Andy Warhol - I lunged across the table at a book signing that Andy was giving and told him that I needed a job. I wore all leather and spiked wristbands. Andy told me, "Make an appointment and come and see me." So I did and he spent hours looking at my photographs. He was interested in every single little thing. Bianca and Jade Jagger were there, and Brigid Polk. Then Williams Burroughs came in. Truman Capote called from some island and it was funny listening to them gossiping on the phone. Andy was saying, "Trudeee!"

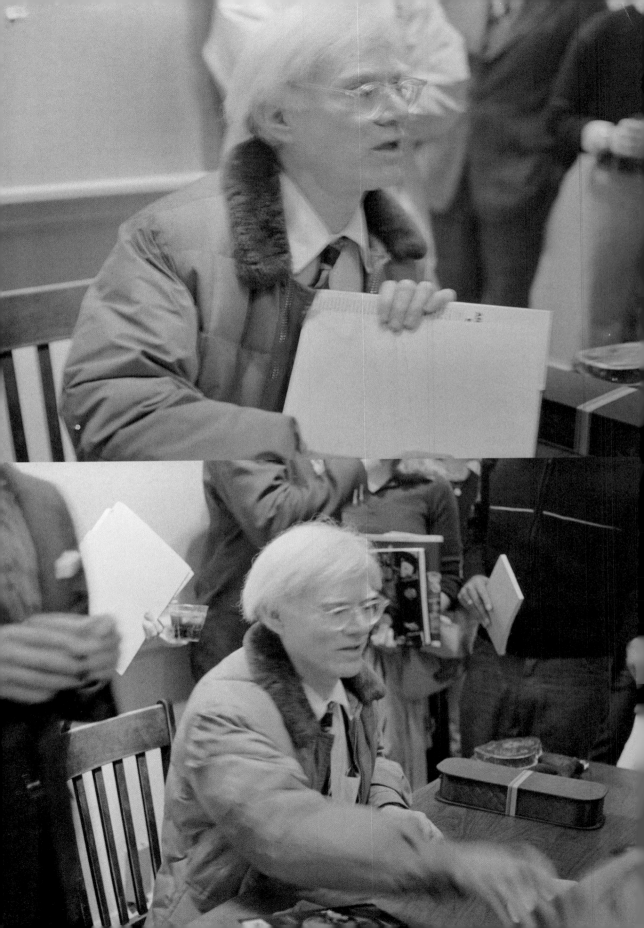

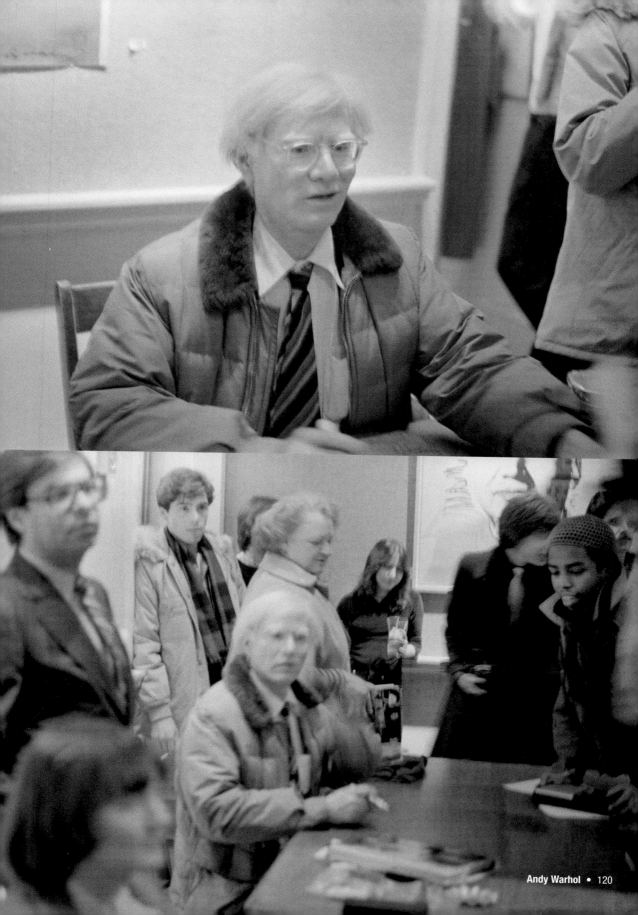

INDEX

ACKNOWLEDGMENTS

Great big glorious thanks to a real life angel on earth, Mr. Brian Chavez. And for work on the cover image, Carl Chen. Also to P. Shelia Hernandez, Super Queen Otto Roseller, Stylish Wess Refat, Charles 'Tasmania' Carroll & MarkO, Tetz, painter extraordinaire Tom Jones, Dadia Whoreletta Cumacrotchie, Brian Goodell, Jungle Jeanne, Southmouth Puta, Carolann Paterson, quaalude Debbi, James Hess, The Ghoul Sisters, Hostess Marc Huestis, Mikki Fabulous, inspirational Nick Nostitz, Willy and Gail Mutant, Josie, Tuni, Gregory, Tracy, Luke, Rayski, Steve, cousins colleen and chris, the East Coast Stellarinas, Michael Biello Studio and Kundalini Cuc. Publisher Jennifer Joseph/Manic D Press must be thanked for encouraging me to search through every single negative and detail the many shows I photographed. Thanks to Scott Idleman at Blink for throwing them down on the pages with style. Your help and inspiration is greatly appreciated. This book brings back great memories.

Above all I'm most grateful to my own Pa&Ma, Zuba and Reets, who raised me to think that every backstage door had my name on it.

This book is dedicated to the memory of Nikom 'Kom' Boonjai.

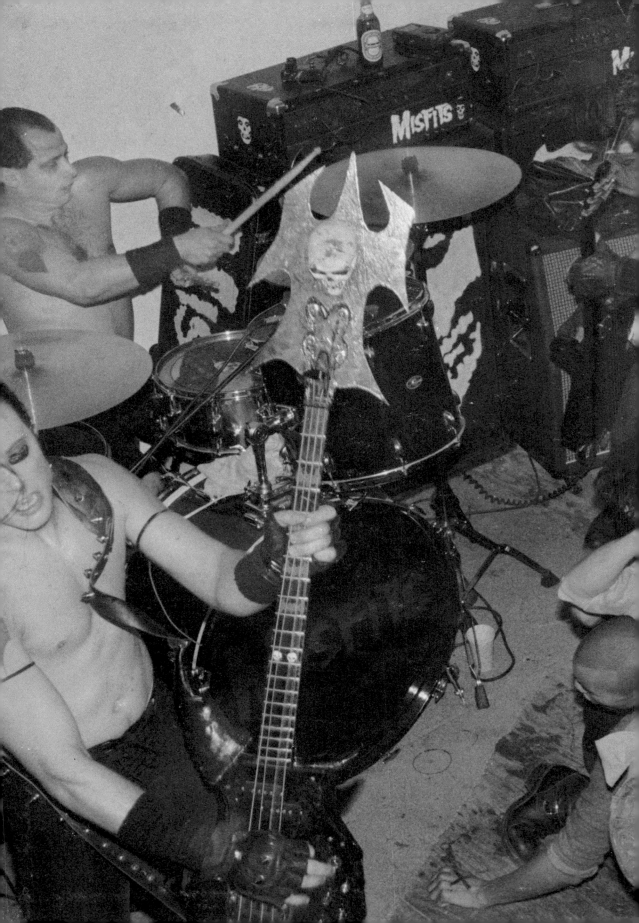